double that followed three walks.

Gary Starkey went all the way for the victory and struck out the side in the ninth inning.

various sports will present ... and special awards, and Robert Hall, president of the Booster Club, will award trophies on behalf of the club.

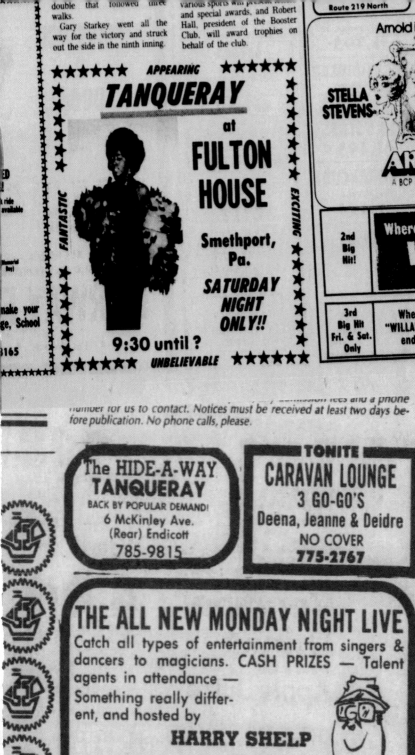
number for us to contact. Notices must be received at least two days before publication. No phone calls, please.

... mission fees and a phone

cov...
yea...
this
Y...
sai...

O...
Q...
for...
lem...
In...
Jew...
my...
now...
so t...
T...
logs...
rece...
I w...
in th...

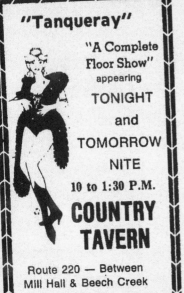
the Clinton of" repeat, Johnny hosts
Dimes. nthony Newley and Char-
The Sons Haven are p
a-thon, t
sponsorship
Carduci an
auxiliary.
The walk
end their tr
ly Home o
walk the
touching
Walkers w
sponsors v
benefit the
by the mi
Anyone
walk-a-the
will go to
the spons

Mrs. n-
exhi
Ikeb

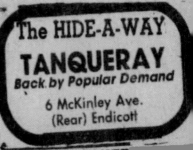
ylvania Fish Commission would
be at the Ridgway Post Office at
11 a.m. with the fish for the
waters.

are
close to

Tanqueray

STEPHANIE JOHNSON BRANDON STANTON

Tanqueray

ILLUSTRATIONS BY
HENRY SENE YEE

ST. MARTIN'S PRESS ❧ NEW YORK

First published in the United States by St. Martin's Press,
an imprint of St. Martin's Publishing Group

TANQUERAY. Copyright © 2022 by Stephanie Johnson and Brandon Stanton. All rights reserved. Printed in the United States of America. For information, address St. Martin's Publishing Group, 120 Broadway, New York, NY 10271.

www.stmartins.com

Designed by Jonathan Bennett

Illustrations by Henry Sene Yee

Library of Congress Cataloging-in-Publication Data

Names: Johnson, Stephanie (Dancer), author. | Stanton, Brandon, author.
Title: Tanqueray / Stephanie Johnson, Brandon Stanton.
Description: First edition. | New York : St. Martin's Press, 2022.
Identifiers: LCCN 2022010197 | ISBN 9781250278272 (hardcover) | ISBN 9781250278289 (ebook)
Subjects: LCSH: Johnson, Stephanie (Dancer). | Stripteasers—New York (State)—New York—Biography. | Burlesque (Theater)—New York (State)—New York—History—20th century. | New York (N.Y.)—Biography.
Classification: LCC PN1949.S7 J56 2022 | DDC 792.7/8092 [B]—dc23/eng/20220411
LC record available at https://lccn.loc.gov/2022010197

Our books may be purchased in bulk for promotional, educational, or business use. Please contact your local bookseller or the Macmillan Corporate and Premium Sal **70889654** by email at

To Mitch

Tanqueray

Foreword

It was a cold day in late November. I'd just finished running on the treadmill at the gym. I didn't have a change of clothes and was covered in sweat, but I figured I could survive the half-mile walk home. As I made the final turn down my block, I noticed one of those people who doesn't seem to exist outside of New York City. It was a black woman in her late seventies. She was dressed in a custom floor-length mink coat

and matching mink hat. And she looked amazing. Under normal circumstances I'd have asked for her photograph. But these weren't normal circumstances. It was very cold, I was drenched in sweat, and I didn't have my camera with me—so I settled on just saying hi. "You look great," I told her. And I intended to keep walking. But the woman had other ideas. Maybe she sensed an opportunity. Stephanie always senses opportunity.

"Let me ask you a question," she said, waving me over with her hand. "Why is it only white boys who wear shorts in the winter?"

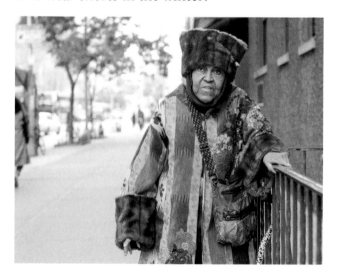

And that's how it all began. I laughed at her question and slowed down to reply, but I wasn't given the chance. Because as soon as I came near, she asked me where I lived. I pointed at a nearby building. "That used to be the white ghetto," she said. "I would sell rhinestone G-strings to all the hookers on this street. Everyone bought G-strings from me because they lit up like Christmas trees in the headlights." Stephanie then launched into a monologue that lasted several minutes. It was clear that this woman was a born performer. She was onstage, and I was an audience of one. This show had no intermissions. And she never paused for applause.

One of the first things she told me was that she'd danced burlesque in the 1970s under the stage name of Tanqueray. She'd been quite successful at it, apparently. "I was the only black girl making white girl money," she said. Then she told me about the first time she had sex. And the time she met James Brown. And the time she sold stolen mink coats for the mob. It was a frantic journey through space and time. One minute we'd be

in the 1940s talking about her childhood in Albany, then suddenly we'd be in the locker room of the '86 New York Giants. Occasionally there would be some connective tissue between the stories, but most of the time there wasn't. It was a jukebox of stories set on random. But all of the stories did share one common trait: they were all captivating. And Stephanie could recount all of them in photographic detail.

As the monologue grew richer and richer, I began to feel the familiar itch I get in the presence of any great story. *I should be writing all of this down.* So I waited patiently for Stephanie to inhale, then I jumped in to interrupt. "I run a website called *Humans of New York*," I told her, pulling out my phone and scrolling through my work. "I'd love to feature you. But I need to run home and grab my camera." I could tell she was a bit confused. And my credentials didn't mean much to her. But she was also enjoying the audience, so she agreed to wait. A few minutes later I returned, still wearing shorts, and took a few photos. Then I pulled out the notes app on my phone. Normally

when I interview someone, there's a process I follow. I'll ask a few broad questions to find the story. Then I'll pull on the thread with a long series of follow-up questions. But none of that applied to Stephanie. I just let her go and wrote down everything she said. A few choice excerpts from those first set of notes:

> *The head of parole fucked my mother 'cause she was prime pussy.*

> *We always sent Brenda out first because she could play the harmonica with her coochie.*

> *Those are the ones with boobies but still have the equipment which the straight men love 'cause they can get done up the butt.*

It was wild, wild stuff. All of it seems so familiar now, because I've spent countless hours talking to Stephanie. These days I can listen to her describe the most graphic sex scene without raising an eyebrow. But on that first day I listened to all of it with my mouth wide open. I'd never heard anything quite like her stories. They were full of wild characters: *Joe Dorsey could pick any lock*

in the city. And he could get by any doorman be-cause he dressed like Wall Street. There was a lot of unconventional sex. *Men would line up at the stage with ketchup and mustard.* But all of it was delivered in the deadpan of someone completely at ease with the subject matter. Nothing seemed to shock Stephanie. As soon as I got back home, I searched the internet for anything I could find on this woman. The only thing that came up was a "slice of life" piece from an *Economist* reporter who'd done a short profile on Stephanie's favor-ite diner. The article featured quotes from several regular customers. One of them was Stephanie: "I used to be a stripper called Tanqueray," she'd told him. "I'm going to make a book out of my life one day." Then apparently he moved on to the next booth. Whoops.

That night I did my best to structure a few of Stephanie's monologues into chronological order. I posted them on *Humans of New York* along-side the pictures I'd taken, and the response was greater than I'd anticipated. Much greater. Quite frankly, people went nuts. After forty years

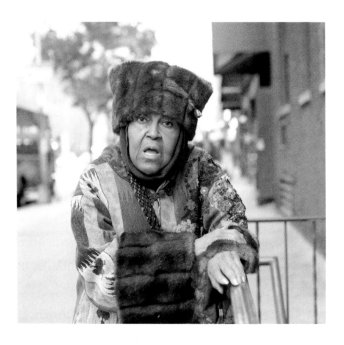

of retirement, Tanqueray had burst back onto the stage in a big way. Stephanie couldn't leave her apartment without being stopped for photographs. Reporters were calling her on the phone. Her old hairdresser, who lived in LA, heard a rumor that Halle Berry wanted to play Stephanie in a movie. When I called to check on her, she was a bit confused by all the attention. "What's the name of your newspaper again?" she asked. But

she was having fun. A lot of fun. She didn't really need to know the details. All she needed to know was that she was back in demand. "I've got a lot more stories," she told me. "We should talk some more."

And that's just what we did. We started meeting regularly for interviews at the diner near her house. Or more accurately—we'd meet at her place, she'd grab on to my arm, and I'd escort her to the diner. Even though the total distance was half a block—it was a harrowing journey. Stephanie moved less than one mph. The first time we crossed 9th Avenue, the pedestrian signal turned green, and then it turned red again—and we were still in the middle of the intersection. Stephanie was obviously in poor physical shape, but she always insisted that we make the trip. The diner was her second home. She knew every waiter. She told me several times that she was planning on getting one of them a stripper for his birthday. She always ordered a burger and fries. The next day she'd complain that she needed to stop be-

cause the salt made her legs swell up. Then she'd order the burger and fries again.

Our original plan was to make a book together, or perhaps a podcast; I would help give structure to Stephanie's stories and then she could tell them in her own voice. Over the next few months, we'd probably meet about twenty times. I'd bring my laptop to each one of these meetings because Stephanie talks fast. It wasn't long before I had nearly one hundred pages of single-spaced notes. I began to hear the same stories again and again. But I was always amazed at their consistency. Even on the third or fourth telling, the stories would match up almost word for word. I could almost finish her sentences for her. But each time I was finally convinced I'd heard every one of her stories, she'd surprise me with a new one. And it would be wild. "How in the world have you never told me this before?" I'd ask. And Stephanie would just shrug.

With every meeting at the diner, my collection of notes grew longer, and our planned book grew longer and longer. But Stephanie's health seemed

to be getting worse. She was wincing a lot during our walks to the diner. Sometimes she'd cry out in pain. I always dreaded the process of getting her into the diner booth. It involved a lot of lifting, and a lot of screaming. Some of the screaming was directed at the universe. A lot of it was directed at me. And when it was time to leave we'd have to do the same thing in reverse. She was so unsteady on her feet that I always wondered how she was able to get around her apartment. But Stephanie is fiercely independent. She never wanted to meet at her place. She always insisted we make the trip to the diner—no matter how long it took.

After the pandemic hit, Stephanie and I stopped meeting in person. I began working on our manuscript, and every few days we'd jump on the phone to flesh out some of the details. Between these conversations, Stephanie would leave me a voicemail whenever she thought of something new. She'd also leave me a voicemail when something pissed her off on television. And she'd leave me a voicemail whenever she dreamed about her ex-husband Carmine. Stephanie had a lot of

dreams about Carmine. So when a three-day period passed without a single voicemail, I began to get worried. Every time I tried to call, there was no answer. Finally I asked a neighbor if he could go check on her, and when he knocked on her door, he heard a faint voice calling from the back of the apartment. Stephanie had taken a bad fall on the floor of her bedroom. The paramedics broke down her door and took her to the hospital in an ambulance. Stephanie was not happy about the door. And she was not happy about the ambulance. She still yells at me about it to this day.

After that fall Stephanie was no longer able to walk. She was having trouble sleeping. The pain in her legs had become unbearable. When I'd push her down the street in a wheelchair, she'd scream in agony every time we hit a crack in the pavement. It was clear that she needed major medical attention. But Stephanie had been living off the grid her entire life. She didn't have any savings or health insurance. We were hoping that the book would raise some money for her. But it was still a few months away from being finalized, and it

was clear that we didn't have that kind of time. So we came up with a new plan. We would have to share the story directly on *Humans of New York*. That weekend we spent a few hundred dollars on wheelchair-accessible Ubers and drove Stephanie to many of the places that were featured in her story. We took hundreds of photos. I cut down our manuscript by about fifty percent, then arranged what was left into Instagram-sized chapters. Then I prepared to post what was perhaps the longest story ever shared on social media. It consisted of thirty-three different chapters, and it would be shared over the course of an entire week. I felt uneasy as we approached the day of publication. I'd already spent months working on Stephanie's story, and now I wasn't sure that anyone would read it. Who was going to stop scrolling through Facebook and Instagram for long enough to read a fifty-page story?

Quite a few people, it turns out. Stephanie's story was the most popular I've ever shared. Over three million people read the twelve-thousand-word story in its entirety. There was a bidding war

for the television rights. And we raised almost 2.7 million dollars to cover her living expenses and healthcare costs. I'd underestimated the audience. And I'd certainly underestimated the power of Tanqueray.

When all the dust had settled, we were finally able to finish that book.

This is the full story of Tanqueray that we were always planning to tell.

—*Brandon Stanton*

Tanqueray, Tanqueray, Tanqueray . . .

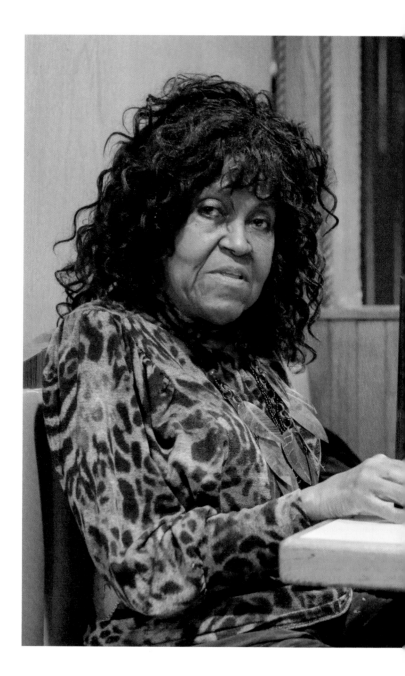

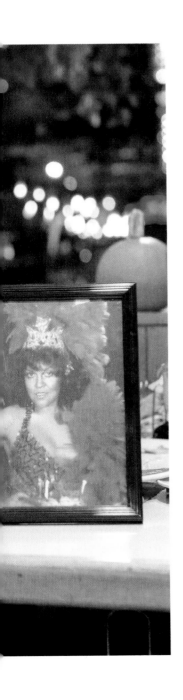

When this photo was taken,

ten thousand men
in New York City
knew that name.
My signature meant
something to them.
They'd line up
around the block

whenever I was dancing in Times Square, just so I could sign the cover of their nudie magazine. I'd always write: *You were the best I ever had.* Or some stupid shit like that. Something to make them smile for a second. Something to make them feel like they'd gotten to know me. Then they'd pay their twenty bucks, and go sit in the dark, and wait for the show to start. They'd roll that magazine up tight and think about their wives, or their work, or some of their other problems. And they'd wait for the lights to come up. Wait for Tanqueray to step out onstage and take it all away for eighteen minutes. Eighteen minutes. That's how long you've got to hold 'em. For eighteen minutes you've got to make them forget that they're getting older. And that they aren't where they want to be in life. And that it's probably too late to do much about it. It's only eighteen minutes. Not long at all. But there's a way to make it seem like forever.

I always danced to the blues. 'Cause it's funky and you don't have to move fast. You can really zero in on a guy. So that it seems like you're dancing just

for him. You look him right in the eyes. Smile at him. Wink. Put a finger in your mouth and lick it a little bit. Make sure you wear plenty of lip gloss so your lips are very, very shiny. If you're doing it right, you can make him think: *Wow, she's dancing just for me.* You can make him think he's doing something to your insides. You can make him fall in love. Then when the music stops, you step off the stage and beat it back to the dressing room.

I grew up an hour outside of Albany. The neighborhood wasn't too nice, but it was better than the black neighborhood on Hill Street. Right now, the house looks like shit, but back then it was completely clean. And my job was to keep it that way. My mother would come home after work and run her hand along the dining room table. Then she'd look at the tip of her finger. If she saw a speck of

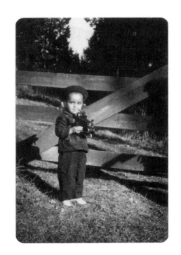

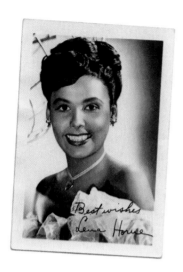

dust, she'd beat me with a belt. I hated that woman. The only thing I liked about her was her style. She looked just like the movie star Lena Horne.

And whenever she walked down the street, both men and women would stop and stare. There used to be a store in downtown Albany called Flah's. And in the 1940s if you didn't buy your clothes from Flah's—you weren't affluent. My mother *only* shopped at Flah's. She bought the best of everything: silk blouses, thirteen pairs of shoes, a hat for every day of the week. No matter how much I hated her—and I *hated* her—I always wanted to dress like her. My mother might have been the only black woman in the capital that wasn't working as a secretary. She was special assistant to the governor. I've always wondered how she rose that high—but I certainly have my guesses. She fit in so well with white society that she wanted nothing to do with

anything black. She never acted black. She never talked black. She talked *about* blacks, but never talked black. She used to tell me that I'd be a lot prettier if she'd married someone with lighter skin. All she cared about was appearances. The only time we spent together was when I took ballet. I was on pointe at six years old. They won't even let kids do that anymore. My mother came to all of my lessons and danced right alongside me. It was the only time we ever bonded. But she couldn't do pointe. Not even close.

My father was around, but that's about all he was. I don't remember him being happy. Or sad. He was just there. He worked at the Montgomery Ward furniture factory, so his fingernails were always dirty. I made up my mind early that I'd never date a man with ugly hands. But he did dress well—I'll give him that. He had the most gorgeous shoes. And he was a pretty good musician too. He brought in a little extra cash by playing the piano. But he spent all his money on a Cadillac, which pissed me off. Because we couldn't even afford to pay our mortgage. My aunt and uncle

were renting out the first floor. And every time I went downstairs to take a shower, my uncle tried to touch my butt. I couldn't stand it. Even today I hate Cadillacs.

All my neighbors were Italians and Jews. I was the fly in a bucket of buttermilk. My first crush was a boy named Neil Murray. He's fat and bald now, but back then he looked like a Kennedy. Every day, he'd carry my books home from school. Until one day the nuns gave us a lecture about how you can't be interracial, so that stopped real quick. But I did everything else the white kids did: ice-skating, snow skiing, horseback riding.

My mother sent me to a private Catholic school, and we were reading all those classic novels: the *Iliad,* the *Odyssey, Tale of Two Cities,* all that stuff.

We even studied Latin. No black kids were taking Latin in the 1940s, but I was near the top of my class.

Every time there was an art thing going down, the teachers would put me right in the middle of it. One Christmas they put me inside a big refrig-

erator box and wrapped it up in wrapping paper. All the parents gathered around. Then the music started, and the box opened up, and there I was— dressed like a doll. Standing on pointe.

I began to dance, and the parents went crazy. My mom was so proud that day. Because none of the other kids could do it, even though they were white. Sometimes on the weekends I'd go over to these kids' houses, and they had families like you'd see on television. Everyone would be talking nice. Like they were happy to be together. Even the dog would be wagging its tail. But there was nothing like that in my house. There were no hugs or kisses. My parents didn't even sleep in the same bedroom.

One time I asked my mother if I could go outside and ride my bike. I was eight years old or something. And she told me: "Wait here. 'Cause your dad and I have something to tell you." She made me wait for hours. I spent the whole afternoon just sitting in my bedroom, watching the other kids play outside my window. Then right when the sun was almost down, she called me into the living room. My father was sitting on the couch, staring at his shoes. He looked like he needed to take a shit. My mother walked over to

me and got down on one knee. She started rubbing my shoulders, and said, "I'm so sorry. But your dad and I are getting a divorce." It was the fakest shit. Like something she'd seen in a movie. I told her: "So what?" And I ran outside to play. I knew she was only acting nice because she was scared of being alone. You know what she tried to tell me once? She was crying about something— something my father did. And she tried to tell me that she never wanted kids. But that she had me anyway so she'd have someone to love. I guess I was supposed to feel grateful or something. But I looked at her like she was crazy. 'Cause she never showed me love. Not once.

My only friends were my dolls. At night I'd pull a blanket over the top of an old card table and pretend it was my home. I'd be under that table, with all my dolls, in their beautiful dresses, and it was like I had a little family.

I'd gather them real close and we'd say a prayer: "Lord, please get me out of here so I can find a family that loves me." I'd say it over and over.

"Lord, please get me out of here so I can find a family that loves me." One night my mother must have heard me in the hallway because she burst into my room. She kicked over that card table and slapped me across the face. When I came home from school the next day, all my dolls were gone.

There was always a copy of *The New York Times* in our living room. And whenever nobody was

around, I'd sit down and read it. I'd see all the fancy things that were in New York: the parades, the plays, the different kinds of restaurants. All the stuff we didn't have in Albany. We had Chinese food in Albany, but not the real stuff. This stuff in New York looked really real. And in Albany we only had one movie theater. The last showing played every night at five p.m. But in New York there were theaters that stayed open all night. I used to run my finger down the showtimes. It all seemed so exciting. I thought: *Wow! That place must be fabulous.*

I was never much for reading the articles. I'd skip straight to the advertisements: Saks Fifth Avenue, Bergdorf's, Lord and Taylor's, whatever. I'd see all the gorgeous clothes. The high fashion. There were no photographs yet. It was only drawings in those days. So I tried sketching some clothes myself.

I was so good at it that I won a contest, and they put one of my dresses in a Katy Keene comic book. I tore out the page and hung it on my wall and decided right then that I was going to be a costume designer. I'd spend hours watching those old black-and-white Hollywood musicals—with Esther Williams doing ballet in the water. The sets were so elaborate. They looked like money. There were fountains, and statues, and huge Roman columns. And there were rows and rows of smiling white women, kicking their legs high in the air. All of them were wearing gorgeous costumes.

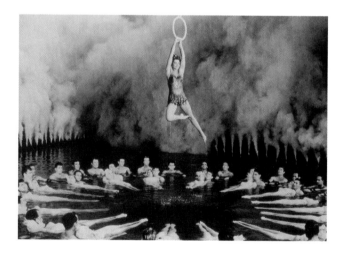

I made up my mind that I was going to be the person who designed all those costumes. Of course I didn't realize there weren't any black costume designers. That's the problem with growing up in a white world. You think you can do anything that white people can do.

The only black friend I had growing up was a little girl at my school named Charlotte. Her family lived on the black side of town, and sometimes after school I'd go to her house to eat. I remember they used to make Kool-Aid in old mayonnaise jars and stack them up on shelves. And they could never afford chicken breasts, so they only ate drumsticks and wings. Charlotte's family didn't have one tenth of the stuff we had at home. But I never felt sorry for her. Because there was a warmth there. There was hugging in that family. Her father would walk by and kiss her mother on the cheek. The kids weren't getting beat all the time. I used to love going over there. But whenever I tried to invite Charlotte over to our house, my mother would do something to make her feel inferior. She'd walk around with her chin in the air and a smirk on her face and say

something like: "Do you want half-and-half in your cereal?" She damn well knew that Charlotte didn't have a clue about half-and-half. But she said it anyway. Just to make her feel inferior. I don't know if Charlotte realized what she was doing, but I realized it. And it made me sick. So I stopped inviting her over. By the time I was twelve, the only black person I knew was an old lady at our church named Ms. Henderson. I didn't know anything about black culture. I didn't know anything about black music. I had an entire record collection, and my favorite album was *Rhapsody in Blue*. That's how white I was.

At some point I started feeling insecure about it. Like I was faking or something. So I asked my mother if I could transfer to the high school on the black side of town. I still don't know why I did it. I just wanted to experience that world. But it was the biggest mistake of my life.

Those black kids were never going to accept me. My name was Stephanie, for Christ's sake. I stood out. My mom worked in the governor's office. I didn't talk slang. No "dems" or "does." I

wore better clothes. I made better grades. That school was hell for me. At the end of every day, right before the bell would ring, I'd look out the classroom window and see three girls waiting for me. They'd be pointing and laughing. They'd wait for me to walk across the lawn, and the moment I stepped off school property—they'd jump on top of me. I'd be on the ground crying and screaming, and they'd just laugh. The leader of the group was named Joyce Ford. She lived in the projects. They were nice projects, but still. Joyce's mother was a whore and everyone knew it. But I'm not sure if Joyce knew it though. Because one day I mentioned it in front of the whole class, and she came after me. She was climbing over the desks. And I don't know how I found the strength to do it, but I beat the shit out of her that day. I guess I was just tired of getting bullied. And after that, nobody messed with me again.

My first sexual experience was with a boy named Buddy Monday. Buddy was on the football team. He was tall. And he was acting all friendly—

like he really liked me. One day after school he asked if he could walk me home. He put his letter jacket over my shoulders. He even told me that he wanted to take me to the prom. And I really, really wanted to go to the prom. He told me all I had to do was have sex with him. I don't think I'd even made out with anyone before. I was so square. But I really wanted to go to the prom, so I agreed. And we did it on my living room couch.

Afterwards I remember thinking: *Is this what sex is all about?* Because I didn't feel shit. But I didn't care. I was going to the prom. It felt like things were going to be different from now on. My mother took me to Flah's and we picked out a beautiful black cocktail dress.

I booked an appointment at the hair salon. But when the week of the prom came around, I still hadn't heard anything from Buddy. Then word got around that he'd asked some white girl named Tony. He never even told me himself. I overheard it in the girls' bathroom. The whole school was laughing at me. And I made up my mind: I was never going to trade anything for sex again.

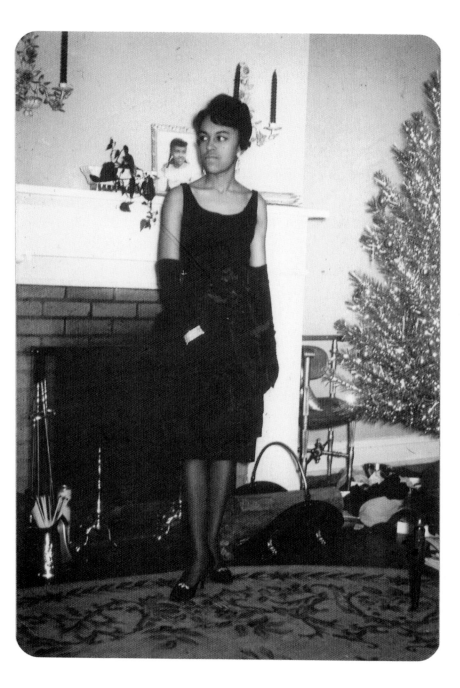

I was feeling hurt after the whole Buddy thing. And not long after that I ended up falling in love with the first black guy who was nice to me. His name was Birdie. And he was from the hood, but he didn't act like a hood guy. He had a car. He took me places. I don't remember much else about him. I just remember that he told me he loved me—which I believed 'cause I was stupid. I didn't know what the fuck love was. I was all alone. There was nobody to discuss girly stuff with: *this happened, that happened,* none of that stuff. So when Birdie told me that all I had to do was pee after sex, I believed him. And you can guess what happened. Three months later I was pregnant. I knew my mother was going to kill me. But Birdie came to my house and showed her this big, fake diamond ring. He spun this story about how he was going to bring me to New York and give me this great life. My mother actually seemed impressed. I think she was happy to be getting rid of me. And I was excited too. The plan was for Birdie to go ahead to New York and find us an apartment. I'd drop out of school and fol-

low behind a few weeks later. I remember arriving in Penn Station, four months pregnant, thinking I was about to have the American dream. Birdie showed up with flowers in his hand. Then he gave me a kiss and told me to go back upstate. Turns out he was already married, and his wife was some sort of invalid, so he decided that he couldn't leave her. I was shit out of luck.

I knew my mother wasn't going to let me come back home. So I decided to leave Albany for good. I was gonna go to New York and live a fantasy life like Esther Williams, with music and dancing and smiling people all around me. But first I needed to sneak back into my bedroom and get the rest of my clothes. I waited until late at night, when everyone was asleep, and I climbed inside the window. I started filling up my bag with all my dolls and my clothes. And I almost made it. I was just about to climb back out. When suddenly the lights flicked on and there was my mother—standing in her bathrobe, madder than hell. She called the cops and had me arrested for burglary. The judge gave me a choice. Either I could give the baby up for adoption and go back to live with my mother— or I could do "one to three" in Bedford Hills prison. I agreed to give the baby up. But I wasn't going back to my mother's. So I told the judge to send me to prison. The whole courtroom gasped. Three weeks later, my son was born. The hospital sent him straight to St. Margaret's children's home, and I was shipped off to Bedford Hills.

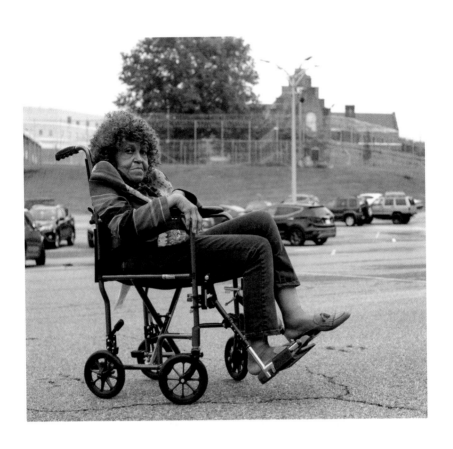

It was a modern prison. There weren't bars on the cells or anything. But I was scared. I was only eighteen. I'd never been around criminals before. Since nobody from the outside was putting money into my account, I had to get a job in the prison factory. Back in the day, all the bras and underpants were made by convicts—so that's what we were doing. I'd always been good at art, so on the

side I started making marriage certificates for all the lesbians. I'd use crayons to draw little hearts and stuff. Then I'd sign it at the bottom to make it look official. In return they'd give me cigarettes—which was money. Pretty soon I had a little reputation. I was like the artist of the prison. The warden even asked me to choreograph a dance for the prisoners on family day.

In the cafeteria I'd always sit next to a Jewish girl named Peggy Black. Some redheads are beautiful. But Peggy was one of the other ones. She was built like a linebacker. She had a big, wide nose and freckles all over her face. She was locked up for prostitution, but I could never figure out what man would want to buy this. Peggy took a liking to me. She always called me Stuff. She'd tell me: "When we get out of here, you're going to be my Stuff." She made this whole plan for me to come to New York and work for her pimp. And I just sort of let her run with it. I knew I'd never have to fuck her because she didn't live on my wing. And I was getting out a long time before her. So I flirted right back. I started calling her Baby. And she took care

of me. She started treating me like her girlfriend. Whenever Peggy got commissary, she'd put it in the system under my name. And she had a job in the kitchen, so I was eating good. She'd sneak out entire chickens between her thighs.

I was hoping for a quick parole. So it didn't help that the corrections officers hated me. There was one dykey-looking officer named Ms. Williams. She was in charge of our section, and she had it out for me from the very beginning. She wanted all the prisoners to call her Daddy, and I wouldn't do it. I'm not calling anybody Daddy. She was just like my mother in a lot of ways. She thought she was so much better than the prisoners. She'd correct their pronunciation. She'd use big words just to embarrass them. But Daddy Williams had never read the *Iliad* or the *Odyssey,* so I knew even more words than her. And I started correcting her right back. That really made her mad. So she started looking for reasons to write me up.

Luckily Daddy Williams couldn't do much damage because the warden took a liking to me. She'd seen my test scores. She knew I didn't belong in

prison. So she kinda protected me. When it came time to go before the parole board, she called me into her office, and she told me the fix was in. "I've got some bad news," she said. "Your mother is fucking the head of the parole board. And you're gonna get denied." But the warden had a whole plan ready. She told me that if I could wait one more month, the head of parole would be on rotation at the men's prison in Dannemora. Then she drew up some fake papers and claimed that I was locked up in solitary.

My board hearing got rescheduled—and the next month I went in front of a whole new panel. All my papers were perfect. I was like the valedictorian of the prison. The warden even wrote me a letter of recommendation—so my parole was approved. Finally I was outta there. And I knew just what I was going to do. I was never going back to Albany. I was going to catch the first bus to New York City and begin a brand-new life.

But before I left prison, there was one more thing I wanted to do. There was a white-haired woman named Roberta who lived on my wing. She came

from Poughkeepsie Mental Hospital, and everyone was kinda scared of her because she had these bad dreams at night and screamed like her whole body was on fire. But she was also kinda famous for reading palms. So the night before I got released, I let her read me. I gave her my last cigarette, and she looked at my hand and started describing all these things. She told me that I'd live my entire life in New York City.

And I'd only be in love once. And that it would be a tough life. And a lonely life. But that one day a lot of people would know my name.

And the craziest shit about it, is that every single thing came true. Well, almost everything. Roberta told me that I'd come into some real big money one day. And that better happen quick. 'Cause I'm already seventy-six.

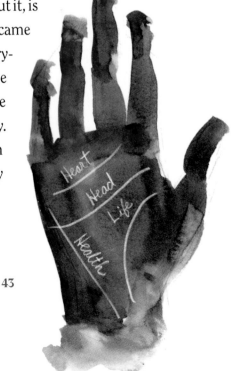

43

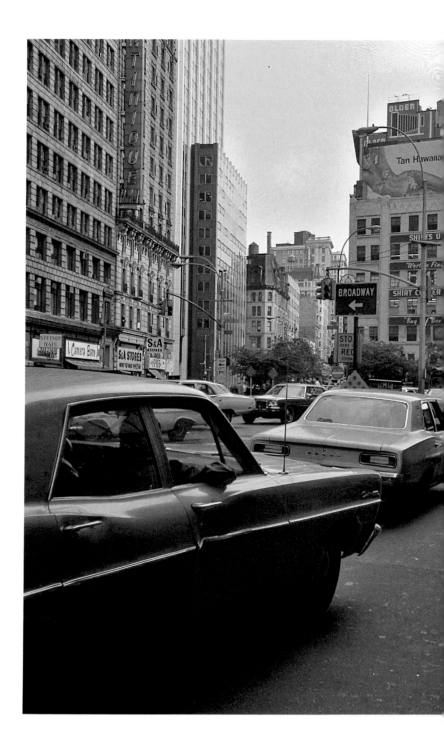

I arrived in New York City on Valentine's Day. It was like being reborn. All my mistakes in life: the pregnancy, the prison time, everything—had been because I was trying to get away from something. But I was finally where I wanted to be. Now my mistakes would be my own. The first thing I did was get a room at the Salvation Army.

I had nothing in my bag but ninety dollars, a pack of baby powder, and a bar of prison soap. My roommate was an older woman named Edna, and she had the exact same bar of soap as me. But neither of us would admit that we just got out of prison. It didn't take me long to figure out that Edna was locked up for prostitution.

She'd spend most of her nights up in Harlem— tricking on 125th Street. All the black guys loved her even though she was fat. Some nights I'd go with her. And whenever she picked up a guy, I'd just wait at the bar until she came back. Then we'd go get something to eat. I'd been black my entire life, but Harlem was the first place I ever ate soul food. It was also the first place that I really listened to black music. And believe it or not, Harlem was the first place I learned about racism. Edna would take me to these house parties on 125th Street. A guy would stand outside to collect the money in a brown paper bag. It was ten dollars to get in. And if you were darker than the bag, you weren't allowed inside.

I got my first job working at a clothing factory

off Washington Square. We were making waiter
jackets or something. At first I was just cutting
threads off stuff, but when the owner found out I
could work an industrial sewing machine—he
moved me up quick. On my days off I'd go
out and explore the city. Back then a subway
ride cost fifteen cents, but I always took the
bus. Because I wanted to see everything:
every park, every square, every skyscraper.
There was none of this stuff in Albany. I'd
usually stop for lunch at a Greek diner
on Park Avenue. Or any other place
that would let a black girl order a salad
and stare at people for an hour. That's
how I learned about table manners.
Which fork was the salad fork. Which
spoon was the soup spoon.

I learned that people with class
always put the napkin in their lap.
And they never cut a dinner roll in
half and butter the whole thing.
They break it off a little piece at
a time and put it in their mouth.

All my life I've watched what white people do: how they live, how they work, how they get from point A to point B. That's how I learned to fit into their world.

After lunch I'd go stand on the corner of 59th and 5th and watch the wealthy people walk down the street. Every single one of these women dressed like my mother. There was real money in New York. We had money back in Albany, but it always seemed like pretend money. Like everything was a "put-on." If a person in Albany had a really nice ring, it was usually to distract you from the polyester they were wearing. But I can read fabric. So I knew the truth. And when you're really rich, everything reads money. That's how it was in New York—money from head to toe. Leather all the way to the floor.

One of the first things I did was get my wardrobe together. I could never afford what these rich people were wearing—I did all my shopping at the discount store—but I managed to get a little something going. I bought myself a hat for every

day of the week, just like my mother. The rest of my clothes were pleather—except for my shoes. People with money only wear leather shoes. So I saved up for three weeks and bought myself some brand-new leather shoes.

At night I'd lie in bed and listen to the sounds of the street. I never wanted to fall asleep, because I didn't want to dream about my mother screaming at me. So I'd listen to all the noise outside and I'd start to feel like I was missing out on something. That's how New York sounds late at night, when you're lying in bed and you're scared of going back to where you came from. It sounds like you're going to lose your place in line. And if you don't get out of bed—the thing that was supposed to happen to you is gonna happen to someone else. I'd make myself so nervous thinking like that. I'd put on my leather shoes and hop an uptown bus to Times Square. I'd walk down Broadway past all the theaters and dream about dancing there one day. Then I'd walk a little bit further, past the adult theaters—where I'd actually end up dancing.

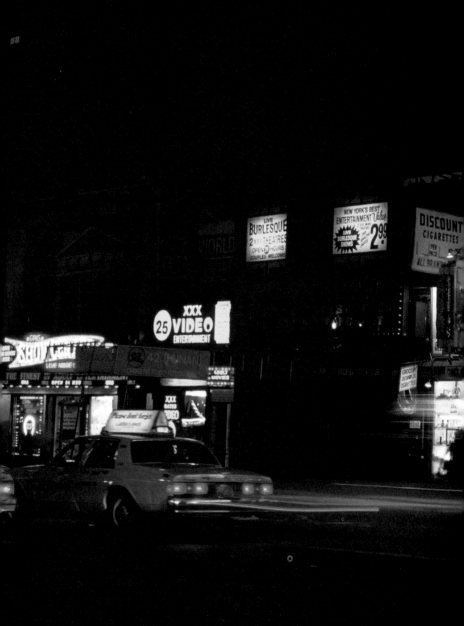

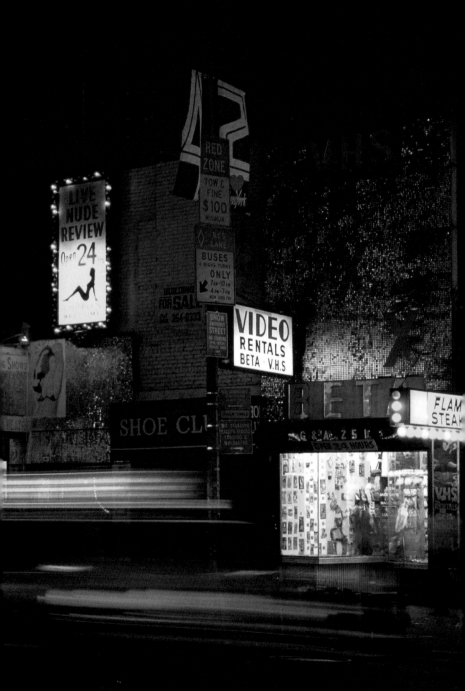

By the end of the night I'd usually find myself in one of the clubs. The most famous club in Times Square was the Peppermint Lounge.

It's a parking garage now, but back in the day it was the place to go if you wanted to hear some music. That's where Chubby Checker invented the twist.

But it was usually filled with tourists, so I spent most of my time across the street at the Wagon Wheel.

It was more like a community. The clubs weren't like they are today. There was no VIP section. No velvet ropes and champagne service. Everyone mingled: the tourists, the hustlers, the entertainers, the pimps.

The first person I ever met at the Wagon Wheel was a pimp named Silky. He was from Cleveland. Nobody knew why, but all the pimps seemed to be from Cleveland. They'd hang out in the clubs while their girls were out working, and they were easy to spot. They'd be wearing

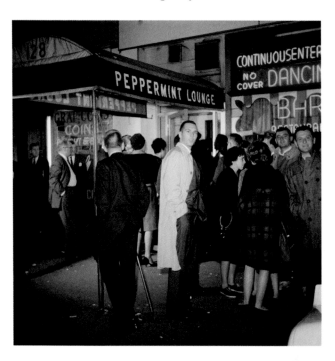

a purple jumpsuit, eight different gold chains, and twenty-five-hundred-dollar alligator shoes. But Silky wasn't a normal pimp. He never beat his girls. And he looked sophisticated. Most of these pimps couldn't tell the difference between eighteen karat and fourteen karat. The jewelers on Canal Street knew it—so they'd send limou-

sines to fetch these guys from the club. They were easy marks. But not Silky. He was more subtle. He wore just the right amount of jewelry, and he dressed exactly like my father. I think I told him that one night. Because he took a liking to me. He always protected me. He never tried to pimp me because he only pimped white girls. And he made all the other pimps leave me alone. He'd tell them I was his sister.

Back in the sixties, every club in New York was putting in a stage for go-go dancers, because a go-go club could make twice as much as a regular club. The girls would dance in cages or behind the bar, and guys would line up to put money in the jukebox.

These girls were getting paid. On a busy night they could make a hundred dollars in tips during a five-hour shift. I had to work a full month at the factory for that kind of money. And I was a better dancer than all of them. But I knew the clubs wouldn't hire me. Because go-go dancers had to be perfect. They couldn't have stretch marks. Couldn't have tattoos. And they couldn't be black.

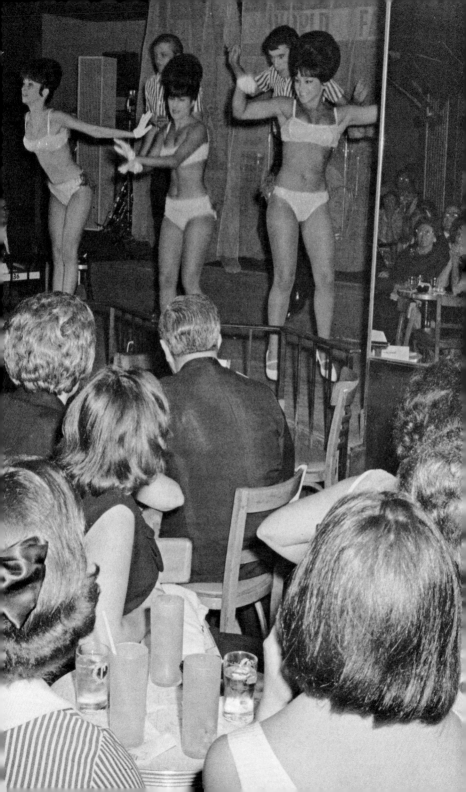

When you go to the clubs every night, you start to see the same people. They'd buy me drinks. They'd ask me to dance. It was like a make-believe family for me. I never knew much about these people. Maybe they had real families. Maybe they weren't as alone as me—but they never made me feel that way. They accepted me. They called me Black Stephanie. I got along with everybody. Especially the mob guys. Every single one of them had a black woman on the side, so they'd flirt with me all the time. And I had no problem with it.

They dressed their asses off. They talked romantic. It wasn't long before I was hanging with a whole crew of Italians. And they started giving me little side jobs so I could earn some extra cash. My steadiest work came from a guy named Joe Dorsey. He was the best thief in the city, but he didn't look like what he did. He looked like Wall Street. His fingernails were always perfect. And his wife was an upscale escort who wore designer clothes. Joe had one of the best hustles in town. Back in those days, rich women would keep their jewelry

and mink coats locked up in storage until it was time for a big event. Then they'd always go to the beauty parlor and start bragging about their fancy parties, and all the nice things they were going to wear. Joe was paying off a hairdresser at the nicest parlor on Madison Avenue. And the moment these women started jabbing, she'd sneak away to call Joe Dorsey. All he ever needed was an address. Because Joe could get past any doorman, since he dressed like Wall Street. And he could pick any lock. So by the time these women got home, their whole place had been looted. My job was to sell the mink coats. I'd wear them to all the clubs and wait until I got a compliment. Then I'd unload it. Joe gave me a commission; plus I always added an extra ten percent to his price. So I was making money on both ends.

At some point I started going door-to-door at the sex theaters in Times Square, selling coats to the girls. There was never anywhere to sit in these theaters. So I'd just sit down in the live sex shows.

I'd always be the only woman there. All the

guys around me would have newspapers in their laps. And the moment that the lights went down, those papers would start rustling. I remember the first show I ever saw—this guy comes out onstage with a teenie weenie peenie. And I started laughing. I couldn't help it. And it made the guy so nervous that he couldn't get his weenie hard. So I started laughing even more. And pretty soon the guys in the audience were laughing too. There was a girl waiting backstage that he was supposed to be fucking. And she comes storming out. She's completely covered in tattoos like the girls are now. And she was pissed. She walked to the front of the stage, looked me in the eyes, and said: "Bitch, if he can't fuck me, I don't get paid." I got real quiet after that. And the lights went down. And the newspapers started rustling.

After the show was over, one of the owners pulled me aside and said: "Stephanie. We let you come in here every day. But if you ever do that again, you will be barred from Times Square." I knew what he meant. The mob owned every single

nightclub in Times Square. All the money flowed up to some guy named Matty the Horse. Everyone knew about him. I never met him, but his goombahs were always hanging out in the lobby of the Times Square Hotel.

One of my best customers was a go-go dancer named Vicki. Vicki was a blond-haired, blue-eyed bombshell. And she loved mink coats. Vicki worked the Peppermint Lounge when it was really going, but she made a lot of money on the side as an upscale call girl. All her clients came through a lady named Madame Blanche. Blanche controlled the high-end prostitution in the city. All the powerful men came to her because they knew she wouldn't talk. But that didn't mean Vicki wouldn't talk. Vicki told me everything. One night I was selling her a coat, and she told me that Madame Blanche was looking for a black girl. The client was Alfred Bloomingdale—the owner of the department store.

It was a role-play thing. All I had to do was go to his hotel room and pretend to be a maid. She prom-

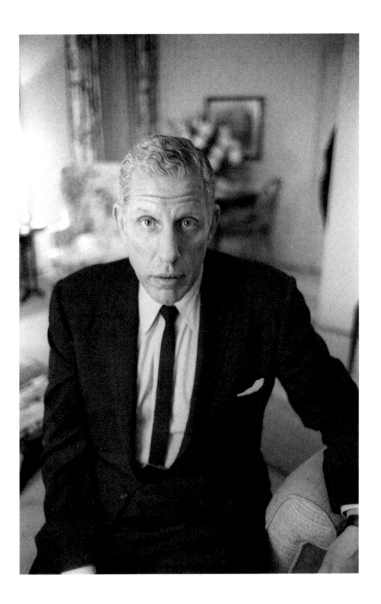

ised me that I wouldn't even have to take off my clothes. And the pay was three hundred dollars—so I agreed. Bloomingdale was set up in a permanent suite at a fancy hotel off Park Avenue. When I walked in the door, he was lying in the bed, wearing one of those smoking jackets like Hugh Hefner wears.

He was surrounded by five white hookers in French lingerie. They weren't even touching him. They were just sorta sitting on the edge of the bed, looking bored. On the bedside table there were stacks of one-hundred-dollar bills. He peeled off three of them and handed them to me. Vicki had coached me so I knew what to do. He ordered me around for a while. I was serving them drinks and picking up clothes off the floor. He gradually got more and more demanding, and I was saying dumb stuff like: "Yessuh, Mr. Bloomingdale. Oh yes, Mr. Bloomingdale." But after thirty minutes I was supposed to switch it up. The plan was for me to start talking back, and he was going to get angry and call me the N-word and whip me with his necktie. I didn't care. I was getting three hundred dollars. But when that time came, he didn't

grab a necktie. He grabbed a leather belt. And that wasn't in the agreement. So I grabbed my coat and got the fuck out of there. Thankfully I got my money up front. That was my only time tricking, but Vicki kept going. Madame Blanche would set her up with the president every time he came to New York. And I'm not going to write his name 'cause I can't afford the lawyers. But he'd always spend an hour with her. He'd send a car to pick her up, bring her to his hotel room, and put a Secret Service agent in front of the door. Get a load of this: all he ever did was eat her pussy!

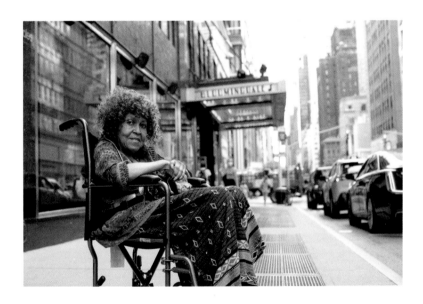

One weekend, the Temptations came into town to play a show at the Copacabana. Nobody black had ever performed there, so everyone was buzzing about it. At the time Vicki was fooling around with one of the singers, so she asked me if I wanted to come out and party with them. I told her no problem. It didn't seem like a big deal to me. Vicki was obsessed with famous people and their money, but I could care less. The way I saw it: It wasn't my fame. And it wasn't my money. So why would I care? We made a plan to meet at a jazz club in the basement of the Americana Hotel.

All of the Temptations were there, but I got paired off with Dennis—who happened to be the finest of them all. We had the best table in the house. And I could tell that Dennis was into me. We were flirting and laughing. Everyone was having a great time, when all of a sudden James Brown comes walking up to our table.

He must have been drinking. Because he pulled up a chair and started jabbing his finger at Vicki, screaming about how the Temptations had no business being with a white woman. He

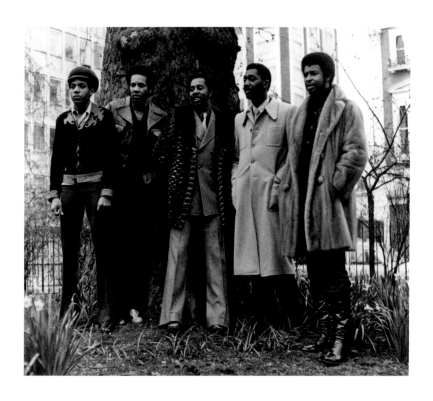

kept saying that there were plenty of sisters who look good. Now I'm listening to all this "black and proud" shit, and I'm getting pissed. Because James Brown was keeping a white girl named Geri Miller in the Knickerbocker Hotel. I knew it for

a fact. Everybody knew it. James had gotten her a floor-length fox coat for Christmas, and every time he got mad at her—he took it back. It was a big joke in the clubs. So I sat there quietly until James was finished with his ranting and raving, then I said: "Excuse me, Mr. Brown, but Geri Miller would like her coat back."

James looked at me like he needed to take a shit. He didn't say a word. He just slammed some money down on the table and walked out. The Temps started laughing so hard that they were rolling on the floor. And when it was time to leave—they invited us back to their hotel room.

The Temps were staying at some fancy hotel off Central Park South. Right when we walked in the door, Vicki started sitting in her man's lap, and he's kissing on her neck. So Dennis starts doing the same thing. I knew what he was expecting to happen, but I don't do one-night stands. So I'm giving him nothing back. After twenty minutes he got tired of trying, so he gets up and disappears into his bedroom. I thought he'd gone to sleep. But ten minutes later he walks back in, and he's

wearing nothing but a leopard silk bathrobe. It was tied so loose that he was just swinging in the breeze.

And I mean swinging low. Like you wouldn't believe. Nice to look at—but no thank you. I had a shift at the factory early the next morning, so I looked at my watch and said: "I gotta get out of here." On the way out, I could hear all the other Temps laughing. It was probably the only time that man had ever gotten turned down. And ever since that night, every time the Temptations came to town—I'd go to the show. This went on for decades. And always on my way out the door, I'd tip the stagehand to pass a note

to Dennis: *Do you still have that leopard bathrobe?* I must have passed him thirty different notes over the years. I knew it was driving him crazy.

The last time I saw him was a few years back at a club downtown. By then he was potbellied but he could still sing his ass off. I got myself a table right up front, and the whole show he was singing straight to me. Both of us looked so different. There was no way he could recognize me. But during the intermission, I passed the same note that I always do. And when he came back out—he was still 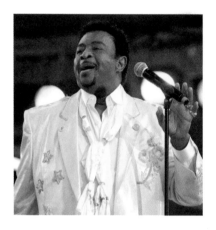 singing straight to me. There was one more concert scheduled for later that year in Queens. I'd made up my mind that I was finally going to reveal myself. But he ended up getting sick, and he passed away before I ever had the chance.

After a few months in New York I was finally starting to get a little something together. I managed to save enough money to get my own room at the Times Square Hotel. It was just a sink and a bed and a radiator, but it felt like the Plaza to me. For the first time in my life, I could close the door at night and relax for a second. But the peace didn't last.

One morning, the owner of the factory called me into his office. I thought I was getting a promotion. But he closed the door behind me and said: "Here's how it's going to work. Either you sleep with me, or I'll give a bad report to your parole officer, and you'll go back to jail." This was some old, scroungy-looking white guy. Exactly what you'd imagine a factory owner to look like. And I'm not saying I would have fucked him if he was any younger—but you've got to be kidding me. So I told him where to put it. I walked out of his office feeling good. I felt like I had some power. But that only lasted for three minutes, because I remembered I was living at the Times

Square Hotel and rent was due next week. At the club that night, I started telling Vicki about my problems. She reached into her purse and pulled out a clipping from *The Village Voice*. It was an ad from a talent agency—holding auditions for go-go dancers. "They'll never know you're black on the phone," she said. "Give them a call." And she was right. They asked my cup size. And my measurements. But they never asked if I was white.

I practiced all week for my audition. Most go-go dancers wore the same ballroom shoes that the Rockettes were wearing, but I could dance in heels. So I bought myself some bright red five-inch heels. And the moment I walked in the door, the guy's jaw nearly dropped to the floor. I was the blackest thing in the world. I think he'd already made up his mind that he was going to tell me no. But I put on some B. B. King and started to dance. And I knew just how to do it. All slow and sensuous.

69

Not like they do in Harlem. Like they do downtown. And when the music finally stopped, he was quiet for a few seconds. Then he stood up, smoothed out his pants, and said, "I think we can work something out."

I went to work the very next week. Since I was the only black girl on Mambo-Hi's roster, I was a little bit of a novelty. And I knew how to sew. I was also the only girl who could make her own costume. It had more beads than anyone else. More glitter. More rhinestones. I even had rhinestones on my fishnet stockings. The guys loved it, and word got around that the black girl could turn out a crowd. I was booked for weeks in advance. But there was only one problem. My manager wouldn't let me work downtown. And that's where the money was. Instead he'd send me to Queens. Or Brooklyn. Or the Puerto Rican clubs in Hunts Point. He kept me out of Manhattan because I was black. He said it was because I was new. But it was because I was black.

The closest I ever got to downtown was a bar in Harlem. It was in the 140s somewhere.

I don't even remember its name, but the place had no class. I'd be wearing my beautiful costume, dancing all slow, really zoning in on the customers, and next to me would be some girl named Sunshine, shaking like a Zulu and shooting grapefruits out of her coochie. The customers were nothing but drug pushers and number runners. So we'd maybe have twenty dollars in tips at the end of the night. Sunshine thought that was real money. But I knew better. There were white girls downtown making a hundred dollars on a slow night. And this place didn't even have a dressing room. We had to change in the kitchen. I'd have to shake out my bags at the end of each night to make sure I wasn't bringing home any roaches.

I begged my manager to take me out of that place. But he wouldn't do it. He said all the new girls had to work Harlem. So I came up with a plan. There was a narco detective that kept coming to my shows. His name was Frank. Frank dressed like a brother, but he was white so everyone knew he was a cop. Whenever he came to the bar, the

whole place would empty out. Nobody could turn their tricks, or run their numbers, or sell their cocaine. But I didn't do any of that stuff, so I had no problem with Frank. We became friends. I told him how much I hated working in Harlem, and I made him a little offer: if he came to all of my shows, I'd buy his drinks. He acted like my biggest fan. He started showing up every night, and all the hustlers would clear out. The bar couldn't make any money. Pretty soon the owner was calling my manager, saying: "This bitch can't work here anymore. We need a new girl." And that was the last I ever saw of Sunshine.

My first steady gig was at a bar called Billy's. I danced there every Wednesday night with a brunette named Lisa. Back in the day there was a famous advertisement for Chesterfield cigarettes, showing nothing but a pair of legs in fishnet stockings. Lisa was those legs. Her customers used to fold bills and tent them on the bar. And Lisa would crouch down slowly, unhook one side of her G-string—just enough to pick up the bill— then stand back up. It didn't take me long to

notice that Lisa was getting ten-dollar tips, and I was only getting a dollar. So I practiced that trick over and over again, until I could do it without falling down.

After a few months I built up a little reputation for myself. That's how it works when you're a go-go dancer. You work a particular place, on a particular day, and you start to get a following. If I worked Monday at a club, I worked Monday forever. Because my customers kept coming back. The other girls would ask questions to figure out if a guy was worth their time. They'd ask about his apartment. Or his car. When the 212 area code came out for Manhattan, a lot of the girls were even asking for phone numbers. But I never asked those questions. Rich, poor, skinny, fat—I treated everyone the same.

My most loyal follower was an auto mechanic named Oscar. For years he came to every one of my shows. No matter where I danced, he'd show up in his greasy uniform. Oscar's wife had abandoned him, and he was raising three kids on his own. Sometimes he'd stay until closing time and

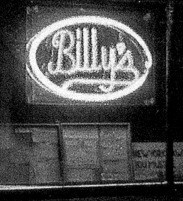

Billy's
TOPLESS

we'd get to talking about our problems. But he never hit on me or anything—he'd just give me advice and stuff. And I always listened. Because the way I saw it—if you're raising three kids on your own, and you're getting through it, I'll listen to how you're getting through it.

Oscar was a lonely guy. He used to save up silver dollars all year long, then on Christmas he'd glue them to the outside of chocolate boxes and give them to his favorite dancers. A lot of the girls laughed at him behind his back. But I really cared for Oscar. He was a great father to those kids. I kept all the boxes that he gave me, and I never even spent the silver dollars.

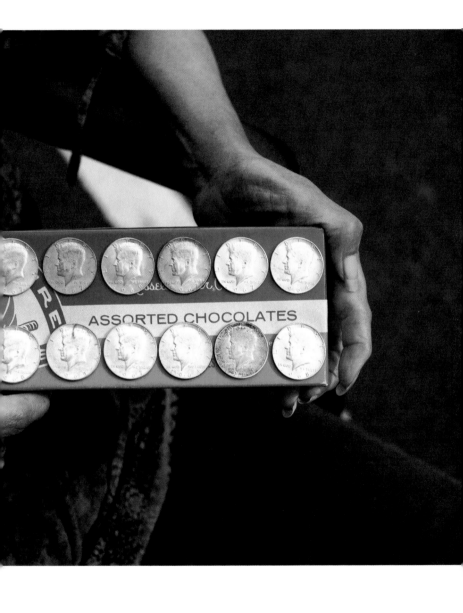

ASSORTED CHOCOLATES

ℰ৵✿৲৹

One thing I did every morning was check the classified section of *The Village Voice*. I was always on the lookout for an extra hustle. And back in the sixties *The Voice* was like the internet. People were advertising all kinds of things. The kind of stuff that maybe you wouldn't want to advertise on a billboard. One morning I saw a notice that Paradise Bootery was auctioning off some extra inventory. Now I knew for a fact that every hooker, stripper, and dancer in Times Square bought their shoes at Paradise. So I made a point to be there. I took all the money I had left and went downtown.

It was summertime and the place was crowded. Most of the men at this auction were owners of regular shoe stores. They were dressed up in suits. And here I come: the darkest thing in the world, wearing hot pants, five-inch heels, and a ripped-up T-shirt. The only shoes I cared about buying were the "fuck-me pumps," so I could sell them to the dancers. I think I had seventy-five dollars in my pocket. That was enough to maybe get two or three pairs of shoes. But I started chat-

ting with one of the men and he gave me some advice. He told me: "Don't bid. Nobody else wants those shoes. So if you don't bid, you'll get them for nothing." And he was right. These shoes retailed for thirty or thirty-five dollars, and I was getting them for fifteen cents a pair. Nobody else bid except for some Hasidic guy who was bidding on everything. But all the other guys got together and shut him down. Every time he raised his hand, they told him to leave the black girl alone. I ended up with so many shoes that day that I had to borrow my friend's truck to get them out of there. The boxes were piled up to the ceiling of my hotel room. And I started hitting the streets with a whole lot of extra inventory.

That's how I've always been. I always needed two things going at once, just in case something fell through. The greatest side hustle of my life was when I figured out how to make lingerie for plus-sized women. I had it down to a science. It's a whole different formula when you're sewing for big women. Sometimes a big woman's stomach will hang down to her crotch. Sometimes she'll

have another butt, and then she'll have *another* butt. You have to allow for that. You can't just start from a pattern and scale up. And I was the only one who could figure it out. I wasn't using stretch nylon. This was the real stuff. Charmeuse satin. Frills. Rosebuds. Just like you'd find in Victoria's Secret. I was getting orders from all over the country.

One night I was sitting in a bar called Wilson's, and I started telling this white guy about my lingerie business. He's asking me all these questions. He wanted to see a sample of my work. And when I showed it to him, he was amazed. He told me that his boss was a Rockefeller, and he wanted me to meet him the next night. I forget which Rockefeller it was. It was the fat one. And he lived in a house near the park.

I'd never seen anything like it. The front door looked like a movie set. I was really nervous to meet the guy, but he was really nice. He sat down with me in his parlor and told me that the whole country was getting addicted to junk food. In a few years, he said, even white women were going to be fat. So we were going to work together.

We were going to be equal partners. And all of us were going to make a lot of money.

That night I walked all the way home. I felt like I'd finally come out the other side. I looked at all the fancy houses along Park Avenue. Then I cut over to 7th and walked down through the Garment District, thinking about which building I'd choose to set up my factory. The next morning I had an appointment at the Rockefeller family office, so we could start going over the numbers. The business manager brought me straight back to the corner office. He told me that I was going to make more money than anybody he'd ever worked with. Then he got up from behind the desk, came up behind me, and started rubbing my shoulders. His breath smelled like old cheese and cigarettes. He told me: "When it's fashion week, and all the buyers are here, we'll put an extra grand in your account to be nice to them." I guess I should have known better. I got out of there quick and went back to dancing.

Carmine
walked into
my life on
New Year's Eve.
I was dancing
somewhere.
Some place in
Midtown—who
knows. And he
walked in with a
group of friends.
Everyone dresses
on New Year's
Eve, but he stood
out. He looked
like Frankie Valli.

I remember thinking it was weird that he didn't have a date. Carmine had a job at the General Motors factory, but he didn't dress blue collar. He dressed like a Guido. Silk tie. Pressed shirt from the Custom Shop. French cuffs with cuff links. And perfect hair. Later on when we were fucking, I'd always try to grab his hair. And he'd say: "Please, Steph! Not the hair! Not the hair!"

But I didn't even talk to him that first night. I might have smiled at him. But I smiled at everybody. So I'm not sure why he kept coming back. He started showing up whenever I danced. He was always alone. And he always dressed perfectly. It was against the rules for customers to flirt with the girls—so I don't even remember how we started talking. But he was charming. He made me laugh. He didn't have any college, but he never sounded stupid. I started to have a little crush on him. One night he got the owner's permission to ask me out. And when I stepped off the stage, he offered to buy me dinner at any restaurant in Times Square. I was a cheap date. I chose Howard Johnson's.

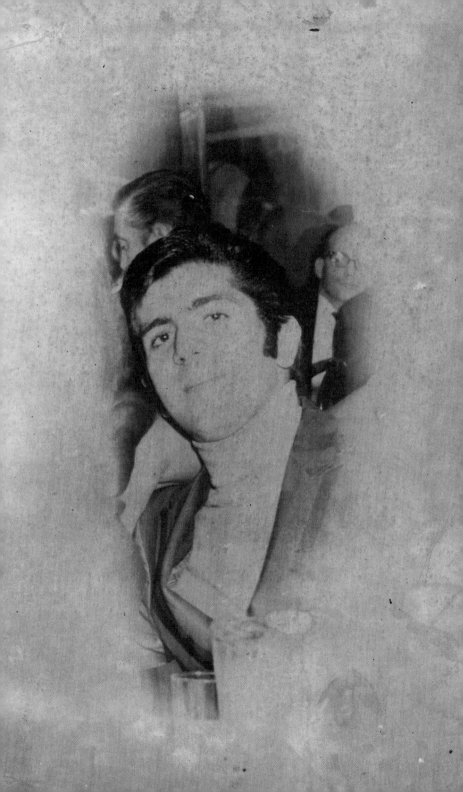

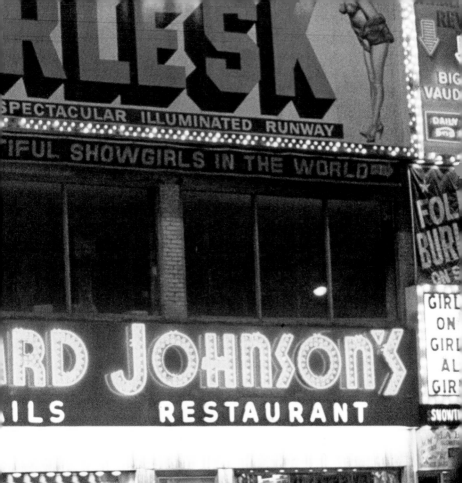

...RLESK

SPECTACULAR ILLUMINATED RUNWAY

...TIFUL SHOWGIRLS IN THE WORLD...

FOL
BUR...
ON...

GIRL
ON
GIRL
AL...
GIR...

SHOW...

...RD JOHNSON'S

...AILS RESTAURANT

BIG
VAUD...
DAILY

REV...

And I ordered the fried clam sandwich. I don't remember what we talked about, but we started going out all the time after that. Carmine was always with me. I'd take him to the clubs on my nights off, and everybody was crazy about him. He even got along with the pimps. He could talk to anyone. And that boy could dance. We used to joke that Carmine had some black in him because he had such good rhythm. All these women would try to pick him up because they didn't know he was with me. And I wasn't one to stop him. He never stopped me either. I could talk to anybody. I could dance with anybody: fast dance, slow dance, it didn't matter. That's one thing I loved about Carmine. I always had my freedom.

Carmine used to keep a blanket in the back of his convertible. Some nights, instead of going home, we'd pick up two sandwiches from Smiley's and take them out to Central Park. We'd lay the blanket out in Sheep Meadow and have sex. Then we'd just sit there talking until the sun came up. One night I was telling him a story about the only

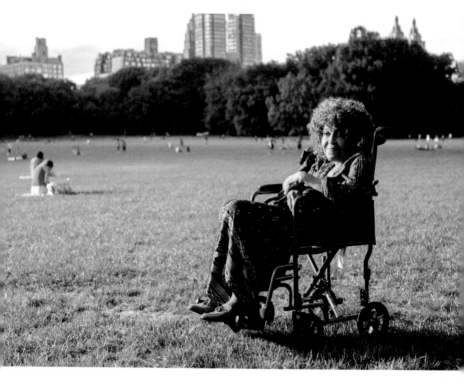

vacation I'd ever been on. My mother had taken
me to Cape Cod to visit my "long-lost Uncle Pete."
It was really just some guy she was fucking on the
side—but I got a free trip out of the deal. When I
finished telling him the story, Carmine turned to
me and said: "Let's go to Cape Cod right now." I
thought he was making a joke, so I kinda laughed.

But he got real serious and asked me again. We ran back to his convertible and drove all night. We didn't have a hotel or anything. We just laid our blanket out on the beach and waited for the sun to come up. We were the only two people out there.

And I don't know why, but I started telling him things that I'd never told anyone before. I told him everything I'd been hiding from everyone else. I told him about my mother. And how she used to beat me. And how I still dreamed about her screaming at me. I told him about the pregnancy. And the prison time. And I told him that when I'm all alone, sometimes I feel like I don't even exist. When I was finished talking, I looked over, and I kinda expected him to not be there anymore. But he was still right there. We watched the sun come up over the ocean. I'd never seen anything like it before. I'd seen it in pictures, but I'd never really seen it. The water was the same color as the sky. Carmine had his arm around me, and I think it might have been the happiest I'd ever felt in my life.

Carmine and I moved into an apartment on 34th Street. We knew they'd never rent to a black girl, so I sat in the car while he talked to the landlord. We celebrated that first night together by cooking hamburgers on the patio, then we decided to take a walk around the neighborhood. And I'm not sure who spotted it first—but there was a tractor trailer parked across the street with its door unlocked. Carmine popped open the back and found a whole load of Charles Jourdan women's shoes. By the time we sold it all, there was enough to cover six months' rent. And we made sure to spread the wealth around. On the weekends we'd throw these huge parties and invite everyone from the club except for the pimps.

Our friend Mickey drove a delivery truck for *The New York Times,* but on the side he sold coke to a lot of famous people. He used to show up at our parties with a punch bowl full of joints and a dinner plate full of cocaine. I never touched the stuff, but everyone else seemed to love it. Those parties went until four a.m. At the end of the

night we'd lay out blankets and people would fall asleep on the floor. It was nice having the same people around all the time. It started to feel like a real home. And Carmine treated me like I'd never been treated before. He bought me flowers. He took me places. We used to get dressed up every Friday night and get dinner in the Latin Quarter.

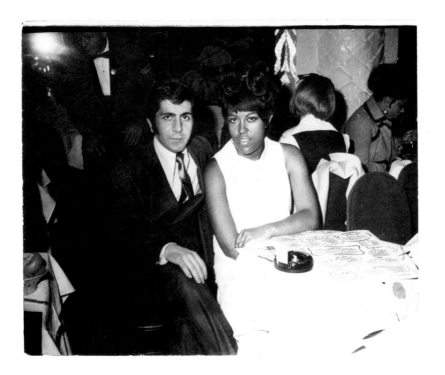

And since so many of his friends were thieves, he was always bringing me presents. My favorite color is purple, so he got me a purple dress. He got me my first real diamond ring. And on my twenty-fifth birthday he got motorcycles for both of us. Every time we got in a fight and needed to cool off, we'd just go out riding. Those were the happiest days of my life. It felt like I finally had a little family. Of course Carmine could never tell his actual family about me. They'd kill him if they knew he was with a black girl. So every year he'd have two Christmases. The one he spent at his parents' house in Jersey, and the one he spent at home with me.

One weekend I rode my motorcycle up to Albany. My old friend Charlotte invited me to a big gala for some social club called M. C. Lawton. You had to be bourgeois black to belong, and all my mother's friends were there. I walked in with my mink coat. And diamond rings. All of it was hot, of course. Carmine bought everything hot. I walked around that dance floor and made sure I spoke to everyone. I flirted with all the black guys

who would never speak to me in high school. I gave them all phony phone numbers. I made a big scene because I knew my mother would hear about it. And sure enough, she called me up the next day. She was pissed. She told me: "I think I hate you 'cause you've done everything in life that I couldn't do." Then she slammed down the phone. And that was the last time I ever spoke to her.

Carmine was a hustler—but he was steady. Our bills were always paid, so I never had to dance much when I was with him. The only job I kept was at a place called the Metropole.

It was a big, three-story club owned by a bunch of mob guys and one connected Israeli. And it was the best place in the city to dance go-go—because they booked by the week and the place was always packed. There were a lot of office buildings around so the customers had money. And the stage was behind the bar so they wouldn't even try to touch you. We always had three girls dancing: two on the floor and one doing sexy moves on a red velvet couch. Things got so hot on that couch that guys

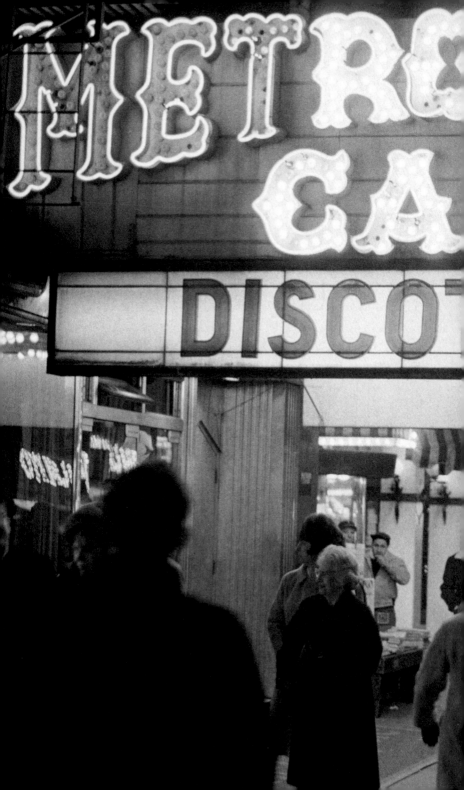

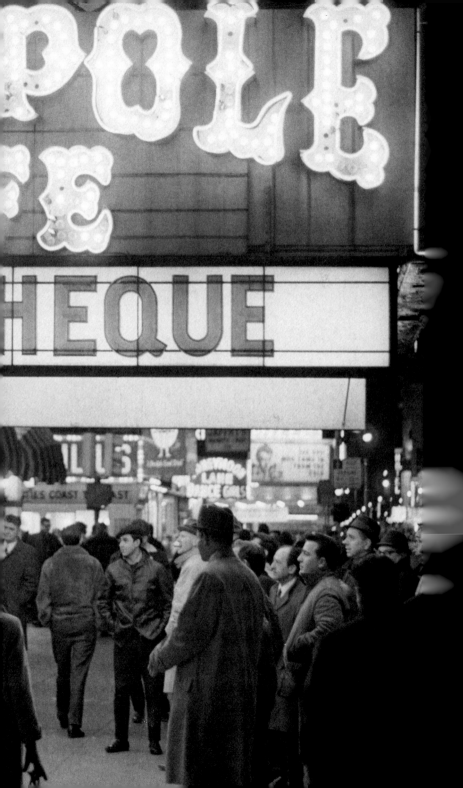

would sometimes try to jerk off at the bar. We called them "shoulder jumpers." Because even if they covered their lap with a coat, you could always see their shoulders jumping.

There was one girl there that none of us liked. She used to walk around with her nose in the air, saying to anybody who'd listen: "I'm going to be a movie star. I'm going to be a movie star."

During our breaks, the rest of the dancers would go across the street to Woolworth's and get some food. But this girl kept sneaking out the back door with our biggest tippers. Now tricking was against the rules. Because if one girl is sleeping with the customers, none of the other girls are getting tipped. So one night I decided to follow her. I trailed her down the block and watched her disappear into the Taft Hotel with one of our biggest tippers.

I went straight to the souvenir store and got some itching powder. They called it "itching powder," but back in those days it was just little pieces of fiberglass. I brought it with me back to the

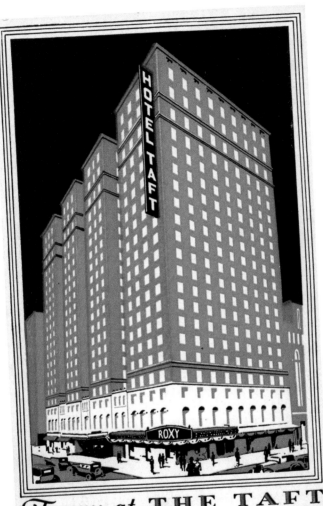

Tarry at THE TAFT
SEVENTH AVENUE · AT FIFTIETH
NEW YORK

break room. Even though we had lockers, all the girls just left their bags lying out. So I found her bag and put itching powder in the crotch of every single G-string. That night she put on a show to remember. She circled the stage like a roadrunner and started grinding on that couch so hard it had to be reupholstered. The other girls were laughing so hard. That's the last night we ever saw her at the Metropole. But she popped up years later in *The Longest Yard* with Burt Reynolds. So I guess she finally fucked the right one.

A lot of my old followers couldn't afford the Metropole. But Oscar still came to every one of my shows. He wasn't allowed to wear his greasy uniform, but he still showed up. He'd always sit in the same seat. He'd order the same glass of Tanqueray. And every Christmas he'd give me the same chocolate box covered in silver dollars. Sometimes when my shift was over, Oscar and I would sit at the bar and talk for hours. He never hit on me once. He was the closest thing to a father figure that I ever had. He always picked up the phone when I called. One weekend Carmine was

in Vegas, and I got diarrhea so bad that I couldn't get off the toilet. I called every single girl I knew. But nobody would come help me. Oscar drove all the way from Brooklyn to bring me a bottle of Imodium. He didn't even ask questions. That's how he was. He's the only one I could completely trust. I told him everything about my personal life. So he's the only one who knew that things had started going south with Carmine.

We'd been living on 34th Street for a few years when a prostitute moved into our building. Her name was Candy or something. And at first I thought Carmine was fucking her, because she kept knocking on our door. But one day the elevator wasn't working, and I caught the two of them shooting up in the stairwell. Carmine swore it was a one-time thing. But I started to notice little changes. He didn't want to go out much anymore. He kept dozing off on the couch. And then my tip money began to disappear. Later I'd find out that Carmine had been using for years. But I'd been too square to notice. He was the only junkie in the world who could keep a nine-to-five.

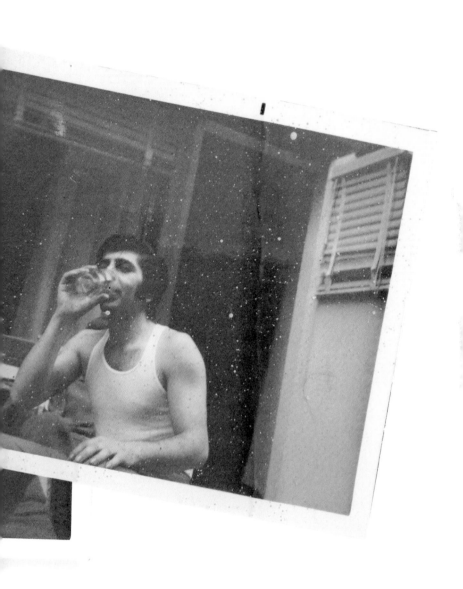

And he was shooting up between his toes, so I never saw tracks on his arms. Everything seemed normal. I never had to tell him to do anything. It would always be: "I'll wash the dishes tonight," or whatever. Junkies don't do that. There wasn't much sex, I remember that. But he'd give me hugs. We'd watch TV together. So for the longest time I never knew. We tried a few programs after he finally came clean. But every time he went to rehab, he'd just meet another connection. Then he'd go straight back to the drugs. I couldn't handle the lies anymore. It was like I was living with someone who wasn't real. And everything he said was part of a script.

I think Carmine sensed what was coming. Because every day he was asking me to marry him. And the worse he got on drugs, the more he asked. I'd always tell him no. It wasn't because I didn't love him—I loved Carmine more than I've ever loved another person. I just couldn't be with a junkie. It wasn't easy to leave. We didn't have any savings. And the apartment was in his name, so I had nowhere to go. At some point I figured in my

crazy mind that if I married him, I could divorce him. And if I divorced him—at least I could keep the apartment. So the next time he proposed, I said yes. We went to city hall. I wore a black dress because I knew it was the end. He didn't know, but I knew.

I still have the last Christmas card that Carmine gave me. It was the Christmas he bought me fake tits. On the card he wrote: *I hope our next five years together are better than the last five.* But we weren't even together for five weeks after that. I went to the courthouse and filed for divorce. I didn't want his money. I didn't want any of his stuff. I even gave him back the motorcycle because I didn't want him to have any reason to come around. He started ringing my doorbell at all hours of the night. He was screaming outside my window. He was out of his mind on drugs, and I called the cops so much that they stopped responding. At the time I'd taken a second job working as a coat check at the Wagon Wheel, and that's where Carmine finally found me. He walked right past the bouncers because everyone knew him.

He stood right in front of me. He looked like he'd been crying. Then he pulled a gun out of his coat and pointed it at my face and told me that he still loved me.

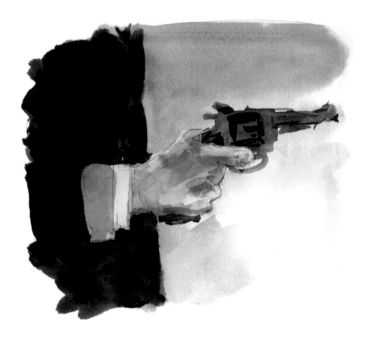

I looked him right in the eyes. I didn't even say a word. But my knees were shaking so bad that I could barely stand up. The bouncers saw what was going on and they wrestled him to the floor. Then they threw him out on the street. But no-

body called the police. Because everybody loved Carmine. That night I called Joe Dorsey and told him what happened. I wasn't selling coats for him anymore, but we were still friends. So he told me not to worry. I knew that Carmine scored his heroin at a burned-out apartment on 50th Street. So Joe Dorsey and his goombahs parked across the street and rolled up on Carmine right after he scored. They told him that they could care less if he was Italian. And they didn't care if I was a black girl. If I ever fell down the stairs, or got a scratch on my face, they were gonna shoot him full of heroin and throw him in the river. He'd look like just another dead junkie. There wouldn't even be an investigation. Carmine stopped coming around after that.

Every once in a while when I was dancing, guys would ask me if I did bachelor parties. And I always said no, because I knew they wanted me to strip. But I wasn't stupid. I knew that dancing wasn't going to last forever. So when things fell apart with Carmine, I started saying yes. It was all

about money. A good go-go dancer could make a hundred dollars in tips over a four-hour shift. But burlesque paid a hundred fifty dollars, and your set only lasted eighteen minutes. My first gig was at a volunteer firehouse in Long Island. I was so nervous that I had to pee every five minutes. And I kept having to stop the performance while they drove away on calls. But I must have done something right because they booked me again on the spot. And the captain drove me all the way back to New York with the siren going. I decided right then to make a career out of it. The first person I told was Oscar. We were having a drink one night, like we always did, and I told him I was thinking about doing burlesque. But there was only one problem: "Stephanie" wasn't sexy enough for burlesque, so I needed a new name. Oscar tried to help me come up with ideas. He kept sipping on his drink and thinking real hard, but nothing was coming. Then after a few minutes, he slammed his glass down on the table and said: "Tanqueray."

It sounded perfect to me. But that name was the last thing that Oscar ever gave me. The next

month, he quit taking his blood pressure medication because he wanted to get a hard-on for a stripper named Crystal Blue. And he ended up having a stroke. He lived for a few weeks after that. He couldn't move much. And he could barely speak. But every day I visited him in the hospital. I put the word out to all the other girls, but none of them came. In the end I was the only one there. He started crying on the night before he died because I think he knew he was close. And nobody had come to see him. All those years, all those chocolates, and all those silver dollars. They hadn't bought him a thing. He died completely alone.

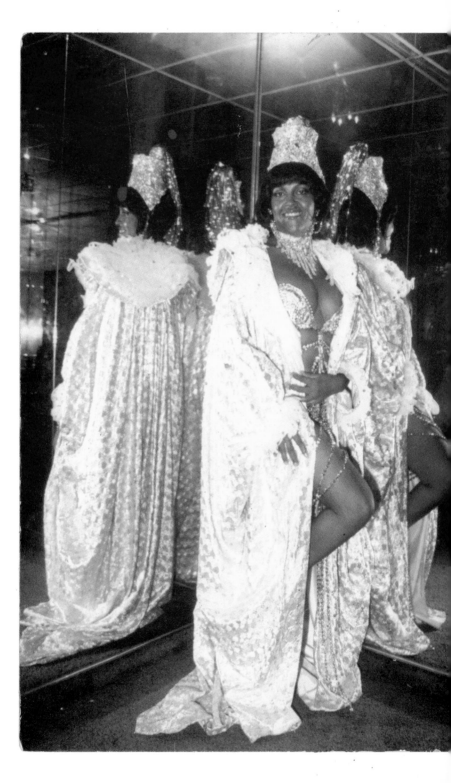

"Burlesque" is a fancy-sounding word, but it basically means stripping. You can wear a three-thousand-dollar costume and strut across the stage like the Queen of England. But during the last number, you better be taking off your clothes. Every burlesque theater in Times Square had two types of dancers: house girls and features.

The house girls work the same place every week, and they always come out first. They're just part of the crew. They don't have it, and nobody knows their name. It's the feature who fills the seats. She travels from venue to venue and always closes the show. It's her name on the marquee. And she's the one getting paid. Now whenever I get into any kind of whatever—I want to be the best. And burlesque was no different. So naturally I wanted to be a feature. Only problem was there weren't no black features. But I was determined to cross the color line because features were making a thousand dollars a week—at least. The easiest way to become a feature was to work strong. Strong meant nasty. Dildos and stuff. And the stronger you worked, the more money you made. There was a girl named Monica Kennedy at the Melody Theater making ten thousand dollars a week.

You know how much ten grand a week was in the seventies—cash? That's because Monica worked strong. She let it be known on the street that she douched with Listerine. And at the end of her act, the audience would form a single-file line.

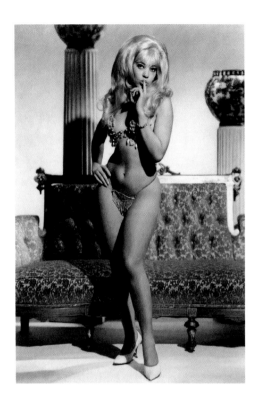

Each guy would be given a hot dog bun, and Monica would shoot hot dogs out of her vajayjay—right into those buns. She had mustard, relish, everything. Nobody left her show hungry. That's how you made ten thousand dollars. Cash. But I could never do it. So I had to figure out another way.

A lot of girls broke into the business by working with an agent. But that was an even dirtier path. The biggest agent in town was named Dick Richards. And if you worked with him, you had to have a ménage à trois with his girlfriend. I wouldn't do it. Plus I knew that Dick Richards would never give his best gigs to the black girl. So I needed another way to stand out. The first thing I tried was a snake. My cousin had gotten a six-foot snake from a pet store, then decided he didn't want it. So I made it part of my show. I would drape it around my shoulders every time I danced. The snake thing worked OK for a while, especially when I was performing in a theater. But whenever I was working the floor at a private party, all the guys would freak out. So I needed some-

thing different. My next idea was to swallow a sword. I took a trip to Tannen's, which was the biggest, most famous magic store in the world. It had everything for magic tricks: trick mirrors, trap doors, boxes where you could saw people in half. Back then the owner of the store was a guy named Tony, and I was honest with him. I told him I wanted to swallow a sword so I didn't

have to shove dildos up my hoo-hah. That really killed him. He gave me a tour of the shop and started introducing me to all the real magicians. He kept asking me to repeat what I'd told him. Eventually we found a fake sword that would roll up in my mouth, but then he had a better idea. He went into the back and brought out a little brown box. Then he opened it up and pulled out a special trick. I'd never seen a trick like this before. It was the trick that put me on the map. In the 1970s, if you were a certain kind of guy, and you heard the name *Tanqueray*—you thought of this trick.

I'd bring it out during my final number, which was usually Donna Summer's "Love to Love You Baby."

The guys would start roaring as soon as the song came on because they knew what was coming. By that time I'd be down to a silk negligee made from thirty yards of silk. And even though I was full nude, I could twirl that negligee so fast that you never saw a thing.

There would always be two baby bottle tops covering my nipples. And right as Donna was hitting the high note—*"I love to love you, babbbby"*—I'd start tugging on those bottle tops, and chocolate milk would shoot out into the front row. It drove all the guys crazy. And I never let anyone near my equipment, so nobody could figure it out. There was a full-blown rumor in the community that black girls make chocolate milk. And I just let them run with it. Because my shows were always full. The minute the doors opened—the guys would be running for the front row. I worked my

way up to feature in less than a year. Nobody had ever done that before. I was just like Jackie Robinson—black number one. Make room for Tanqueray, because here I come.

I was the only black girl making white girl money. The other dancers weren't too happy about my success. A lot of times they'd go out together after a show, but I was never invited. I didn't really fit in with them anyway. No offense—all of them were gorgeous. But they all had problems. I don't think any of them wanted to be doing what they were doing, so they were always drinking and snorting cocaine. My only friend in the community was a girl named Ronnie Bell. She was drop-dead gorgeous. I mean, next level. With or with-

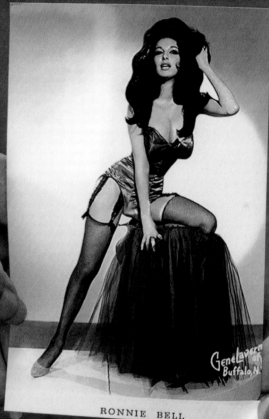

RONNIE BELL

out makeup. All the other dancers were jealous of her—I'm not sure Ronnie realized it, but they were. Because she stole the show whenever she worked. This girl would have double gigs some nights. One show at eight. One show at ten. And the moment you saw her, you understood why.

Ronnie had a tough childhood. She grew up in New Orleans, but she ran away from home at the age of fourteen to join the circus. Then she saved all that money and put herself through medical school. During the day she worked as a registered nurse. Ronnie never had to do any of it. She was married to some finance guy. She lived in a big house out in Queens. She only danced because she enjoyed it. That's why we got along so well—neither of us took ourselves seriously. We used to work a theater together outside of Fort Dix, where the black soldiers trained. I was always the feature. The promoter would lie and say I was Ms. Black Universe or something. Ronnie and I used to meet at my apartment and drive out there together. As soon as we got on the Jersey Turnpike, we'd take off our shirts and wait for a big rig to

come by and see us. It never took long because Ronnie was stacked. And I mean stacked. We had one of those CB radios in the car—breaker nine or whatever. So we'd egg them on. And next thing you knew we'd have a convoy of tractor trailers escorting us down the highway. And when we finally got off the exit for Fort Dix, they'd all start honking their horns. *TAH-TAH-TAH.*

I could bring home three thousand dollars a week if I was working the road. That was real money. Only the porn stars were making more than that, because nothing draws a crowd like having your face in a movie or magazine. In the 1970s—the biggest porn star around was Gloria Leonard.

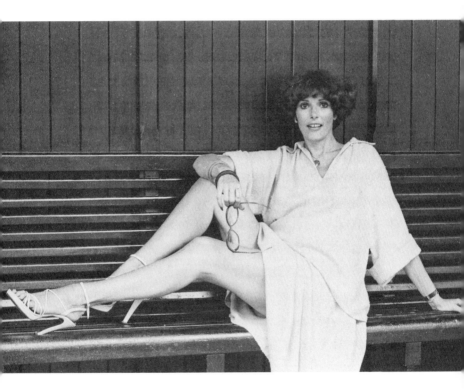

She was like the Meryl Streep of porno. I used to work with her a lot. Whenever she had a new movie screening at Show World, I'd go along with her to warm up the crowd. But Gloria wasn't just a famous actress. She was the publisher of *High Society,* which was one of the biggest adult magazines

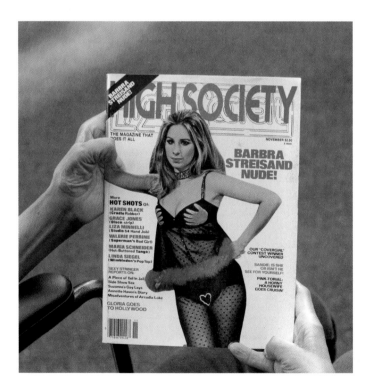

going back then. Gloria was always trying to convince me to do a spread in her magazine, but I kept saying no. Those shoots were full nude. But Gloria and I became good friends because she loved listening to my stories. One day we were laughing about something that happened, and she tells me: "You'd make a lot more money if you wrote for me." I told her: "C'mon, Gloria. It's all an act. My sex life is boring. There's nothing to write about." That's when she leaned in real close and whispered: "It doesn't matter. Just make it up." I went home that night and started typing. And when I showed Gloria what I wrote, she agreed to give me a column every other month. We called it Tattle-Tails by Tanqueray.

The pay was five hundred dollars, and it only had to be two pages. The writing part took me forever because I'd failed typing class three times. But the ideas came easy. All I did was take a regular situation and make it X-rated. I pretended like I was having sex everywhere: grocery stores, movie theaters, the DMV. I even wrote about having sex in prison. And people believed I was actually doing

that shit. Gloria published everything I wrote. She said I was the only writer that they never had to edit. I still wouldn't let her put my picture in there—just the headshot. But it didn't matter. Because everybody read *High Society*. You couldn't buy that type of publicity. And after the first issues came out, I was like famous. Gloria would send boxes of the latest issue to all of my gigs. Guys would be lining up on the street to get a signature. And my salary went up—big time.

ting of stream litter containers during their regular meeting this week at the Crosby Grange.

The group will be at the Keating Sportsmen's Club from 1 p.m. today, painting the trash cans, which will be placed along Potato Creek at various intervals from Betula to Galico Bridge in Keating Township.

Also discussed at the meeting was the club's Trout Fishing Contest, which will run from April 13th to May 28th.

The next meeting will be held on April 9 starting at 7:30 p.m. at the Crosby Grange.

Creek
llstone
ill be
ng to
strict
r the

1,100
East
will be
Trout.
at the
Penn-
would
ffice at
r the

Everybody
wanted
a piece of
Tanqueray.
I was getting so
many calls that
I had to hire an
answering service.
Before long I had
every account in
the city. I mean

everybody: the investment banks, the sports clubs, the unions, the Masons. FDNY was my account. Transit was my account. I used to bring Ronnie with me every time I danced. We were having so much fun. I remember one night we were working the Friars Club together. They were roasting some television host that came on at eleven thirty, and this guy starts choking on a chicken bone in the middle of Ronnie's act. Somebody turned off the music and started screaming for help. Ronnie

was a nurse, so she knew what to do. She yanked
the guy out of his chair and did the Heimlich right
there. He spit that chicken bone across the room,
and Ronnie just went on with her show.

We'd get five hundred dollars for every gig, and
at the end of the night we'd split it down the middle.
The NYPD was the only account we ever made pay
up front, just in case the crap hit the fan and we
needed to get out of there. Those parties were wild.
All of them would be gambling and doing cocaine.

After they cracked the Son of Sam case, I
danced for one of the lead detectives. And he was
dressed entirely in drag. Sometimes an entire pre-
cinct would rent out a boat on the Circle Line and
ride up and down the Hudson all night. Ronnie
and I would just set down a portable radio and
get to work. The cops were great. They treated
us like royalty. One night a rookie got so drunk
that he threw Ronnie's costume into the Hudson.
They stopped the entire boat and made him jump
in and get it for her. A lot of times those parties
would go until four a.m. And by the time we got

back to Ronnie's house, we'd be so tired that I'd just spend the night. Her kids were asleep in the other room, so we'd always share the same bed. One time she rolled over and started rubbing up against me. I said: "C'mon, Ronnie, forget it. Don't even go there." We never talked about it again. But there was nothing to talk about. I got it. She was lonely just like me.

Everything was fine when the music was playing. When people were laughing, and clapping, and shouting for more. But I knew I was tanking. Even when I was on the stage and having fun—I was tanking.

Some nights I'd go back to the dressing room and look in the mirror, and I'd realize that I don't even exist. Nobody's clapping for Stephanie. They're clapping for Tanqueray. And sometimes I'd get so depressed thinking like that, I'd just start crying. I'd feel like running away and hiding from everyone. At least when I was a kid, I could crawl under the card table with my dolls. But that pretend shit wasn't working anymore. I was too old to fake like someone cared about me. But whenever I started to fall apart, I'd pull myself together and think about how lucky I was to be Tanqueray. At least I was successful. At least I had a career. At least when I'm Tanqueray, and I'm around people, I make them smile. I make them laugh with my stupid jokes. They're not trying to hurt me. But Tanqueray never came home with me. She always stayed out on the stage. It was Stephanie that walked out the back door, and nobody cared about her. Nobody except for Carmine.

A few years after our divorce, he reached out through a mutual friend and asked if we could

talk. They both came over to my apartment together. Carmine looked nice. A little older—but nice. He was dressed like the old days. He told me that he'd started a new life as a limo driver, and he wanted to work things out. He promised he was off the drugs. I listened to his whole speech, but then I told him that I wasn't sure. I was scared. I couldn't tell if he was on drugs or not. He seemed clean, but he had seemed clean when I was living with him. And if he started acting rough again—I had nobody to call. I didn't know any mob guys anymore. I think I told him that I needed a few days to think about it, and that I'd give him a call. But I knew I was never going to call him. As soon as the door closed behind him, I fell on the floor and started to cry.

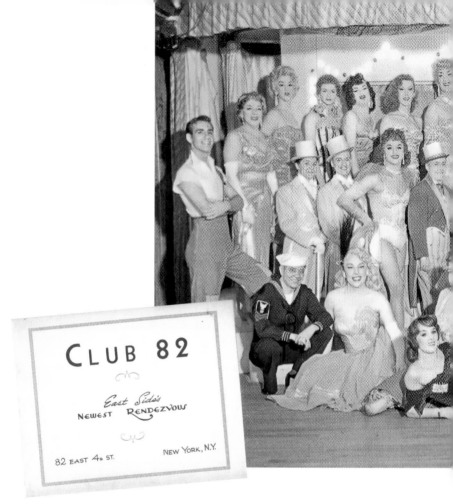

CLUB 82

East Side's
NEWEST RENDEZVOUS

82 EAST 4th ST. NEW YORK, N.Y.

Whenever things got too quiet,

I'd usually go to a gay club. They're the only place that I felt comfortable.

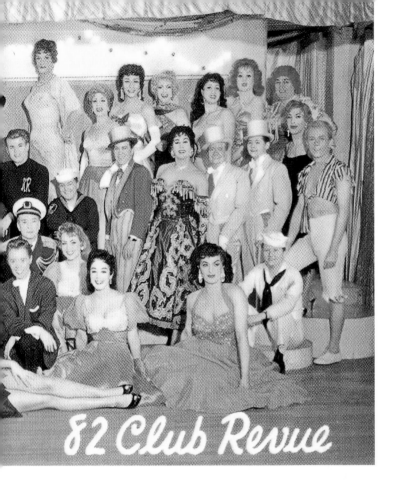

82 Club Revue

Nobody knew who I was. Nobody was hitting on me. Nobody was even looking at me. There was a place that opened up near my apartment called Club 82.

Every Wednesday night, they had a contest for female impersonators. All the waiters were lesbians dressed in tuxedos, and the show was amazing. It wasn't like today. None of the drag queens looked like Uncle Joe in a dress. They were going for realness. Perfect makeup. Perfect hair. I remember thinking: *Wow, these guys look better than me.* There'd always be one real woman on the stage, and if you could guess which one it was, you'd get a bottle of champagne.

There was a performer named Chaka that nobody could read. She always wore a blond wig. She had curves. Her voice wasn't deep. And her act was fabulous. She'd lip-synch to whatever song was hot in the day, and she was known for bringing her mother onstage with her. This was just some regular-looking mother. With glasses and everything. But she'd really get into it. Most drag queens weren't even speaking to their mothers, so everyone thought that was cool. At the end of their number, the entire stage would be covered in dollar bills.

Chaka never came out of character, even during the day. She wasn't always talking loud to get attention. She just lived her life as a regular woman. She worked a regular job at the makeup counter at Macy's, and not a single person knew. Chaka was also a legendary thief. I used to visit her counter to buy a tube of lipstick, and I'd leave with all kinds of shit. I learned so much from her. She's the one who taught me how to do French tips on my nails. She taught me how to make my own eye shadow. She became like a sister to me. We'd go to movies. We'd go to Broadway plays. I

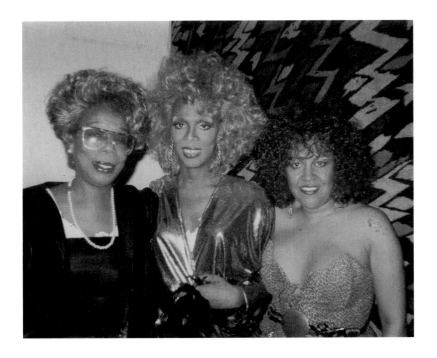

think Chaka was just happy to be hanging out with a real woman. And so was I. It was too hard to make friends in the straight world. Most of my girlfriends would get jealous of my success. Or they'd get married and have kids. All my life, the gays were the only ones who'd never turn on me. They'd die on me, but they never turned on me.

The drag community was mostly black and Latino kids that couldn't afford to go to the clubs. So once a month they'd throw a giant ball up in Harlem. This shit was serious. It was like a competition to see who looked the best. The winners got trophies that were over five feet tall. But you were only allowed to compete if you belonged to a house. The houses had wild names like House of Xtravaganza and House of Warhol. There was never no actual house because most of these kids were sleeping on the street. A house was more like a family. Most of these kids were runaways, so it was the only family they ever had. There'd be a house mother, and everyone would hang out at her apartment. And the goal of every competition was to win a trophy for your house.

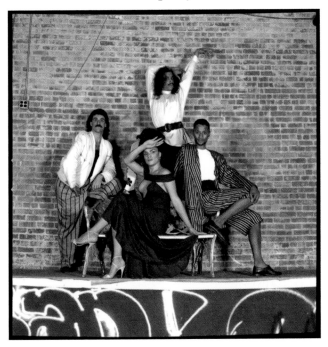

The balls always went down on a Saturday. They'd rent out a VFW hall or someplace else they could get for cheap. Everyone brought their own booze and food. The doors opened at ten p.m. But since all of these kids were turning tricks on the pier, nobody would get there until one. And by the time they walked in the door, they'd be completely transformed. The costumes were amazing. Better

than anything in a Hollywood musical. Feathers. Jewels. Rhinestones. Nobody wore the same thing twice. And the fabric was always top notch, because the gays were excellent thieves.

Chaka and I would always ride out to the balls together. She'd come straight to my apartment after her shift at Macy's, and we'd get ready.

In those days I was buying all my clothes off thieves in the community. There was a seventy percent discount. But you had to take what you were given, so I was dressing like a drag queen. Everything was designer. And everything was over the top. I even had the weaves and fake eyelashes. One night we were out at the clubs and a Hasidic rabbi tried to pick me up because he thought I was a tranny. I had to tell him, "Baby, this is real fish!"

I remember when people started whispering about something called AIDS. It was hush-hush in the beginning. And nobody took it seriously. A lot of these kids were homeless. They couldn't afford to go to doctors. They weren't watching the news at six o'clock. They were doing what they had to do to survive. If you're a young gay kid

who can't get a job, and some guy is offering you a hundred dollars on the pier, and he doesn't want to wear a condom, you're going to take the money. Even if you know about something called AIDS, you'll take the money. Because you need to eat.

People started losing weight. Then you'd hear that this one died. And that one died. The balls started to get less and less crowded. Then they just kinda stopped happening. Because in order to have a ball, you have to have different houses. But when everybody's dying, there's no house.

Chaka kept performing right up until the end. Nobody even knew she was sick. The year she died she threw herself a huge birthday party at the club.

Everyone came. There were even people from Europe at that party. At the end she got up onstage and did a show, and nobody knew. She seemed fine. She was on fire that night. We noticed her mother wasn't up there with her. But we thought maybe she was just switching things up. We found out later that her mother freaked out when Chaka got sick. It embarrassed her. She didn't want her coming around anymore. And when Chaka finally

passed away, word got out in the community that her mother intended to bury her as a man. I was so pissed when I found out. On the day of the funeral, I put on my grand entrance outfit. Purple jumpsuit. Purple suede thigh-high boots. A stole with fifty black foxtails. All my jewelry. All my diamonds. And a beret so wide that I had to take it off to get in the cab.

I walked into that funeral and sat in the front row. I had a single purple rose and picture of Chaka in a beautiful gold frame. When they got done doing the eulogy, and talking all that crap, I walked straight up to the coffin. There was Chaka, dressed like a guy. She was wearing one of those smoking jackets like Hugh Hefner wore. No make-up. No hair. No breasts. And she was wearing gloves because they couldn't get her nails off. I took off those gloves and placed the purple rose in her hands.

Then I leaned my picture of the real Chaka up on the railing, so everyone could know what she was supposed to look like. I walked straight over to the mother, whispered my condolences in her ear, then flicked around so fast that all the foxtails hit her in the face.

My dancing gigs began to fall off in the eighties. But it didn't matter to me. Because I've always had more than one hustle going on at a time. Sewing was always my fallback. Through all my reinventions and re-creations, I never stopped sewing. It was one thing that nobody could ever take away from me. I didn't need a college degree. I didn't need a stage. Or music. Or lights. I could sew anywhere. Even if I was homeless on the street, I could still make the best sequined G-string in the city. Everyone in the adult industry came to me. Whenever there was a new trend, or someone figured out a new kink, I was right there in the middle of it. I just switched it up. All my costumes were sewn to the specific measurements of the person. My secret was dental floss.

You can peel dental floss down until it's a bunch of different strings—and it's stronger than thread. A belly dancer taught me that. So my stuff never came apart.

I was known for my custom. Most designers used paper patterns. They'd make something once and sell it a bunch of times.

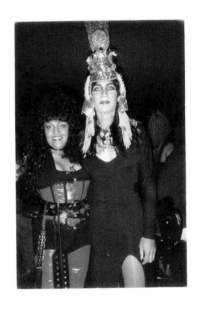

But not me. I usually had one big project going at a time. And everything I made was built to the specific measurements of the person. When Vanessa del Rio needed a dress that looked like a flamenco dancer— she came to me. I covered the entire skirt in sequins. It was so heavy that I had to sew handles into the side just so she could lift it. Then I built her a turban with beaded fruit: beaded apples, beaded oranges, beaded bananas. I topped it all off with some bird-

cage earrings with little birds inside. That shit took me forever. But when she stepped out on-stage, the crowd went crazy. And that meant more business.

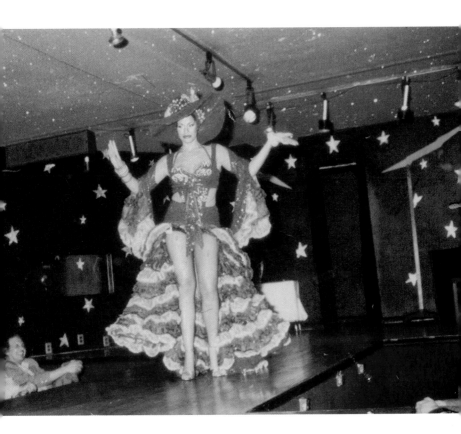

My steadiest client was Robin Byrd. Every man in New York knew about Robin. She hosted a cable access show on Channel 13 that came on at midnight. She had strippers and porn stars on that show—full nude. It was basically soft-core porn. And I made all the costumes for the show. This was before the internet, so all kinds of people were watching. A lot of kids in the Bronx saw their first set of titties on that show.

I made costumes for all of Robin's performers. And whenever I made a delivery to her studio, we'd usually get to talking. She was just like me. She always had something extra going on the side. During the commercial breaks she would advertise her own phone sex line. She'd have gorgeous young models twirling a phone cord between their fingers, saying: "Call me, call me, call me." She was charging $2.99 a minute just to talk on the phone, and that seemed like easy money to me. It was all verbal. You didn't even have to wear makeup. So one time when I was dropping off a costume, I asked her for a job.

It was the fakest shit. When you watched those

commercials, all the women had blond hair and blue eyes. But if you dialed the number, you'd be talking to a grandma from Staten Island. There might be ten of us working a shift. All of us would be sitting in cubicles. And whenever the commercial came on, our phones would light up like crazy. It was all computerized or something. The guy could hit a number for the thing he wanted. *Press 1 for Sex. Press 2 for Dominance. Press 3 for Foot Fetish.* Most of these women were square. Nobody wanted the dominance or fetish calls—so that lane was open. And I made that my specialty. I was the only girl on the Robin Byrd phone line working with sound effects. I used to have a little whip that I'd hit my thigh with. And I always kept two glasses of water on my desk, just in case the guy wanted to get peed on.

You got paid by the minute, and eleven minutes was the sweet spot. Because if you could hold a guy for ten minutes you got a ten-dollar bonus. And hitting that bonus meant the difference between good money and shit money. Before I came along, nobody was holding calls for the full ten minutes.

These girls had no clue. They'd get into the sex right away, and guys would be jerking off like the world was about to end. They'd never last more than five minutes. But I was coming from the burlesque world. So I knew what an eighteen-minute set was supposed to look like. You need some buildup. You gotta make them wait for the nitty-gritty. My specialty was the foot fetish calls. And I hit my bonus every time. Because I always made them wait for the feet. It went like this:

Start the clock.

"Hey, baby, I'm so glad you called. You caught me just in time. I'm coming in from a night out. Sorry I'm breathing so hard, but I just walked up four flights of stairs. I'm covered in sweat. And this dress is so tight. Just give me a second to cool down. Whew. That feels better. I've been walking all night in these five-inch heels. I could really use a good foot massage. That's exactly what I need right now. There's nothing better. You don't by any chance massage feet? Do you?"

148

At this point the guy's saying, *"Yeah, yeah, yeah."* He's breathing like he needs an inhaler. But that's when you've got to slow him down. Because there's eight minutes left on the clock. You've got to get him talking about himself. Ask him where he's from. What kind of girls he likes. Stuff like that. And once enough time has passed, you get on with the show:

> *"Before we get started with that massage, I'm gonna need some help taking off my shoes. But please, baby. Go slow. Because my feet are so sore. And I don't want you to chip these bright red toenails. Oh, your hands feel so good. But I want to feel them a little bit more. I think you might need to remove my stockings. Can you do that for me? No, no, not that way. Here's how we're going to do it. I'm going to sit here. And you're going to get down on your knees, and you're going to put your mouth on my stockings. And you're going to pull them all the way down. And if you want, when you get down to my toes, you can kiss them a little. Only if you're into that kind of thing."*

At this point in the call, you've got to listen to the breathing real close. If he's breathing regular, you're fine. But the moment you hear the breathing speed up, you've got to back him up. 'Cause the moment he cums, he's gone. And that ain't gonna cut it. Because we've still got three minutes until the bonus. So you say something like:

"Where are your hands right now?" Then he'll answer. And you say: *"Take your hands off yourself—you naughty boy. Did I tell you that you could touch yourself? You're not allowed to cum until I tell you. Since you're being so selfish, I need to teach you a little lesson. So here's what you're going to do. I want you to take my stocking and put it over your head. Do you like that? Now take a deep breath. I want to hear you. Breathe in deep. I've been walking all night in those stockings. Breathe it all in. Deeper."* One minute to bonus. *"Tell me what I smell like. Tell me exactly."*

At this point the clock will have almost run out. So you just listen to him huff and puff a little bit,

watching the clock the whole time. Then the moment it hits ten minutes, and you've banked that bonus, you get rid of him as soon as possible. I'd usually say something like:

> *"Take that stocking off your head. And jerk off into it. And make sure I hear you cum."*

Click.

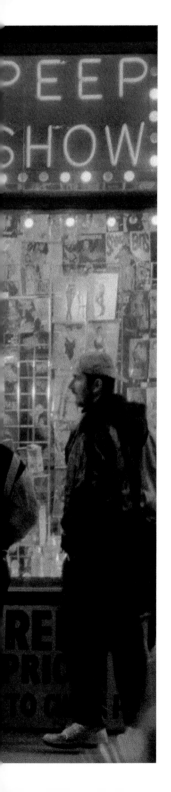

I always worked at night. Every job I've ever had—I worked at night.

My shift began at eleven p.m., and the sun would be coming up by the time I left the office. On the way home I'd usually stop to get a bagel and a copy of *The Village Voice*.

One of the things I loved to do is look at the classified sections. I've always loved to study the ways that people try to get attention. Even prisoners would run ads in there, looking for women. I don't remember what it was about James's ad that caught my eye. He was serving seven years in Rahway State Prison. He had some college under his belt, so he wrote something smart sounding. I was impressed. And I must have been a little bored because I decided to write him a letter. The next week, he wrote me back and included a picture. I was like "wow." This man was built. So I wrote him another letter. And another. Until finally we decided to meet in person.

There I was—the famous Tanqueray. Putting on makeup one Sunday morning so I could drive two

hours to see a convict. Don't ask me why. I was just tired of the bullshit. Every guy I ever dated wanted Tanqueray. They expected me to come home, slip off my heels, and put on another set of heels. I didn't have the energy for it anymore. That's where so many of the other girls messed up. They got older and they got scared, so they married a client for the security. These girls were too stupid to realize that the guys were only marrying them because a diamond ring is cheaper than paying for dances every night. A client is always a client. Even if you've got a ring on your finger. That marriage will only last as long as you can keep your heels on. And no matter how many times he says it, he doesn't love you. He loves the character.

I think that's why I went to see James. When he was writing me those letters, he didn't even know who Tanqueray was. He only knew Stephanie. And I'm thinking he's locked up, so at least he can't cheat on me. It was summertime when I went to visit. We sat in lawn chairs out in the yard, and we spent the whole time just talking. He didn't seem to mind when I told him I was a

dancer. And he told me he didn't belong in prison. It was all a big misunderstanding. He'd gotten locked up for robbery, but his cousin was the one who did it. He was spending all his time in the law library, filing appeals and stuff like that. He even had one of those groups fighting for him—the Innocence Project, or whatever. He promised me that he was getting out soon, and he was going to buy me a house, and we were going to have this wonderful life together. He even gave me a cheap ring that he'd bought off a guard.

This probably sounds stupid, but James was the most normal relationship I've ever had. Even though he was locked up in prison. He treated me like I wanted to be treated on the street. He had a tape recorder in his cell, and he'd record little poems. *You are the rising sun,* and stupid shit like that. But I thought it was sweet. He'd send me a card on my birthday. He'd send me roses on Valentine's Day. And he was the bookie of the jail, so he'd even send me money. I was the only woman getting money from the inside. Other prisoners were begging their girlfriends to smuggle cash

in their coochie. But James sent me five hundred dollars one Christmas. He even took out a life insurance policy in my name.

He introduced me to his entire family, and we got along great. They lived in Jersey, and I'd drive out to see them all the time. His mother liked me. His sister liked me. We'd call each other on the phone. We'd have cookouts on their back porch. On the weekends I'd bring my little niece into the city and we'd get manicures together. I'd take her to plays. All the stuff that a normal aunt would do. It felt really nice. It started to feel like I had a little family.

The only thing that bothered James is that I never fucked him. The prison had trailer visits, but you had to be married. And even then the waiting list was really long. During the summertime a lot of women would have sex with the prisoners right out in the yard. The warden let it all go down because he thought it calmed the prisoners down. And the guards would be watching from their towers with binoculars. I thought the whole thing was disgusting. So I was going to

make him wait. We'd make out and stuff, but that was it. I could tell he was frustrated. I think the other prisoners used to rib him about it. But he never pushed me on it.

James asked me to marry him in January of 1979. I think it was mainly for the trailer visits, but I tried to make it special. I spent weeks planning an engagement party at the prison. Even the warden was in on it. He let the whole thing go down as a gift to the prisoners. I brought along two strippers, a belly dancer, and the same MC who did amateur night at the Apollo. All the prisoners were, like, starstruck. James brought me out onstage before it all went down and introduced me to the prison. But it was weird. He introduced me as his friend Stephanie. Not his girlfriend. Not his fiancée. But his friend. I remember wondering what that was all about, but I kinda forgot about it because I had a show to run. Everyone had a blast. The warden let us go for three hours. The dancers got really into it. One of the guards grabbed the Polaroid camera that they

used for visitation days, and took so many photos that it ran out of film. At the end of the night, the warden confiscated every single one.

We got married on Valentine's Day. I bought James a pair of brown velvet slacks and a beige shirt. Then I made myself a brown velvet suit so we'd match. We reserved the chapel three months in advance, but there was a huge snowstorm the night before. The entrance was blocked by huge piles of snow. So we ended up exchanging vows in the Laundromat. The machines were so loud that I could barely hear what was going on. I just waited for the chaplain's lips to stop moving and I said, "I do."

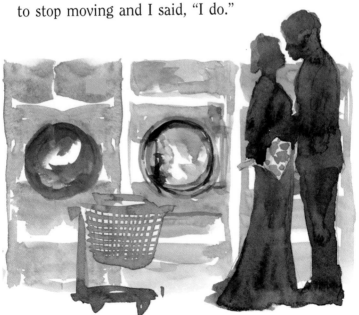

Our marriage was good for about two seconds. Because right after he slipped the ring on my finger, James pulled me close and said: "I always wanted to marry someone in the adult film industry." I should have ended it right then.

A few months later I decided to write a story in *High Society* about James's prison. I think I was coming up on a deadline, so I did the same thing I always did. I just took a regular situation, and I made it X-rated. I wrote that I went to visit a prisoner, which was true. But then I wrote that there was a giant orgy in the yard. So I decided to join in. There really were women fucking prisoners in the yard, so it was kinda true. Every story I wrote was kinda true. It may not have happened to me. But I'm sure it happened somewhere to somebody. Unfortunately James wasn't really a fan of literature. When I went out to visit him the next week, he had the latest issue of *High Society* rolled up in his hand. And he had this real angry look on his face. I guess a lot of the guys had seen it, and they didn't know that shit was fake. So they started

Tattle-Tails

by Tanqueray

This month, our Tattle-Tail goes to jail to discover the delights of delinquent lust. If you relish the thought of being locked up "inside" with Tanqueray, write to her c/o HIGH SOCIETY MAGAZINE.

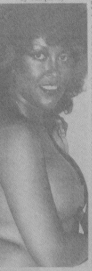

The following item appeared in the back pages of my local underground sex newspaper last spring: *Handsome male, inmate 6'2", 190 lbs., Gemini, wishes to correspond with females of any age.* Well, I've always had a long-standing fascination with convicts and prisons (I'll stay up all night to watch those old prison movies with tough guys like James Cagney and Humphrey Bogart) and, I admit, a secret desire to get it on with a guy *behind* the big gray walls. So, I decided to write this "handsome male inmate" a naughty note; I also included a sexy snapshot of myself.

Four days later he (Jim) answered my note with a phone call—talk about being eager! Was the picture really me?

"It's really me," I assured him.

A charmer, huh? His voice grabbed me right away. It was rich, deep and quite a turn-on. We talked about other replies he'd received to his ad. One lady had sent him a super-hot note detailing all the wild stuff she wanted to do to him—in his cell! (So, I wasn't the only girl with a sex-in-the-slammer fantasy!) As he described the heavy-duty action she had outlined for him, I could hear him getting more and more turned on. I, in turn, was getting wetter and wetter between my legs as my pussy lips became engorged with blood. I almost moaned out loud when he got to the part where she "threatened" to ram his cock all the way down her velvety throat and suck him until his exploded. His excitement was bringing me closer and closer to orgasm, so I quickly got out my trusty, ten-inch dildo, which I inserted in my dripping hole as he talked on, unaware of what I was doing!

My dripping pussy grasped the artificial penis tightly, and I reached an incredible, throbbing climax! Not wanting to let him in on my "secret cum," I pretended to be very angry and informed him that if he was into making obscene calls he had the wrong number! I hung up abruptly. Seconds later he rang me back, apologizing for getting carried away.

He kept calling me every day, and I kept putting him off. But he wouldn't give up. He started sending me lusty letters that stirred up the juices in my pussy, and which also gave me some great ideas to masturbate by! But I wanted to see what he looked like, and if his face matched his sexy, masculine voice. I'd fuck him in a minute!

Two days before I was scheduled to visit my horny honey, I received a photograph of a gorgeous, perfectly built hunk of male flesh. He was wearing a pair of tight jeans—and nothing else. From the top of his head to the bottom of his toes, he was just too perfect looking to be true. I wanted to eat him right up and run my tongue over this piece of ass. Would I fuck him? You bet I would, and I began planning my trip right away. (That night I jerked off to his picture, too.)

The trip to the prison was a little uncomfortable (it was the middle of summer but well worth it. I dressed for the occasion in a low-cut blouse that showed off my juicy 36D's very nicely—maybe a little too nicely?—and a sexy wraparound skirt. As is my custom during summer, I didn't wear panties.

I was escorted into the huge prison yard where everyone (inmates and guards) ogled and stared at my body. The yard was surrounded by 40-foot-high walls made of cement. On top of the walls guards stood in towers and within the walls, five or six guards patrolled the yard. Hundreds of folding chairs were sprinkled throughout the area. They were even selling hot dogs and sodas!

It seemed like years before Jim came out to meet me, but when I saw him, it was love and lust at first sight. As he walked toward me, I felt a sensational stirring in my thighs. I was taking him in, every inch of him. He came up to me and gave me a long, sensuous kiss. Danger alarms sounded as I felt his stiff cock rubbing against my crotch. My body was melting fast, pleading "fuck me." I was visibly impressed with his rather large, prominent bulge.

He told me that he hadn't kissed a lady in years. Well, I was going to do something about that.

We found two chairs and sat by the wall, he with his back to it and directly in front of him. Placing both feet on the wall, I gave him a little peek up my skirt. Leaning over, I kissed me again for a much longer time and shoved a hand up my skirt. When his fingers landed on my juicy pussy, he proceeded to finger-fuck me—slowly, the way I like it. Soon, he worked four fingers between my lips, causing my pussy to squeeze him. A pulsate in agonized excitement. I attempted to suppress my excitement, I felt myself getting tighter and tighter. The orgasm was a mile a minute. The pleasure. As we hoared our suit slipped his fing Sex is strictly prisoners and penalty for getting days in solitary and without any visiting Our visits became I'd sit on the chair

giving James shit. They'd say: "She's fucking every-
one else, why isn't she fucking you like that?"

He started making more and more excuses
for me not to go and see him. On Saturdays he'd
tell me there was a basketball game. On Sundays
he'd tell me there was a football game. We were
supposed to spend New Year's Eve together. We'd
been planning it for weeks. I'd bought a new dress
and everything. But I got a call at three p.m. and
James tells me that he's going to bed early, and
that I shouldn't come visit. I didn't have anywhere

else to go. So I put on my
party dress and went to
see a psychic instead. Her
name was Yolana. She did
her readings out of a wel-
fare hotel, but she was al-
ways right. This woman
was solving cases for the
FBI. It was snowing hard
the night I went to see her,
so I was ten minutes late.

Psychic Yolana Lassaw believes that Barbara Bockwith met a violent
death, and that the discovery of her body will trigger drug-related investi-
gations which will "blow the lid off Pensacola." World-known parapsy-
chologist Dr. Hans W. Holzer says Lassaw is "always 90 percent correct.

But the moment I walked in the door, she said: "He's cheating on you."

The next morning James told me not to visit because he was watching a football game. But I drove up there anyway. I'll never forget the guards' faces when I was going through registration. They were like "oh shit," because they knew what was going down. James was sitting in the visitation room with another girl. I walked right in and sat down next to them. The girl looked scared as shit, but James tried to play it cool. He told me she was just a girl who brings him weed. Like that was gonna work. He ended up paying for the divorce. Because he never wanted anyone to know that a woman would divorce him.

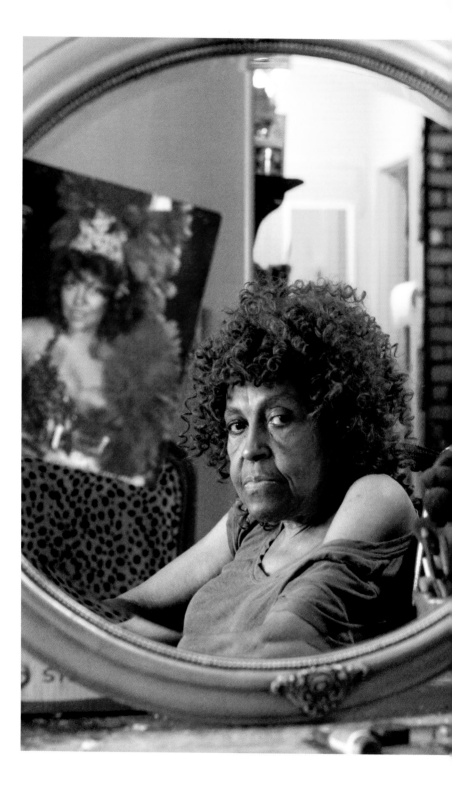

I can't tell you the last time I danced burlesque... It wasn't some big thing. They don't throw you a retirement party at the Sheraton. The phone just stops ringing.

It gets quieter and quieter until one week it's so quiet that you sorta decide you can make more money doing something else.

If anything, I was kinda happy about it. I could finally calm down on the makeup and start wearing dungarees. I remember the first thing I did was go out and buy a pair of loafers. But they didn't seem to fit right. I'd get this sharp pain in my leg every time I walked more than a few blocks. The doctor told me I'd been wearing heels for so long that my calf muscles were completely shrunken. And the only way to build them up again was to wear lower, and lower, and lower heels until I could walk without pain. I guess when you've been one way for so long, it's not easy to be something else. But I had no choice. There's no next step on the ladder when you're dancing for tips. The moment you step off that stage, you've got to start again at the bottom.

So that's exactly what I did. But I wasn't worried. I'd been reinventing myself for my entire life. You wouldn't believe all the things I've done: I've managed a brothel, I've made adult baby clothes, I've

done makeup for cross-dressers. I have so many stories. Sometimes I'll remember the things that happened to me and I'll just start laughing. I hope when I get to heaven God shows me a movie of my life. But just the funny parts. Not the in-between parts, 'cause then we'd both start crying. Underneath all the laughs and the gags, it was always about one thing: survival. Tanqueray was a lot of fun. But Tanqueray was Stephanie. And Stephanie was a teenage runaway from Albany: doing what she needed to do, and being who she needed to be, to get what she needed to get.

The city used to be so much better. Maybe it was better 'cause I was younger. Or maybe it was better 'cause it was better. But it used to be better. There's no place to go anymore. The adult theaters are gone. The clubs are gone. Times Square doesn't even exist anymore. I mean, it's still there—but somebody figured out they could make a lot more money if they turned it into Disneyland, so that's exactly what they did. Now it's just billboards, and flashing lights, and some guy dressed up like the Cookie Monster. There isn't anywhere to go.

There's nowhere to go that people can get to know each other. Or if there is a place to go—you need a corporate credit card just to afford a drink. And not everybody has it like that. What about the regular people? They used to have choices too. Maybe they were bad choices, but at least they were choices. For people looking to have a good time. And to forget about things. And to be less lonely for a second. Sure, New York is more family friendly now—but not everyone has a family.

Carmine ended up moving down to Florida to start a new life. Both of us dated a lot of other people, so there'd be long periods where we didn't talk. But we never lost touch. We even talked on the phone a few times last year. It was always about regular stuff. I never started crying, or said: "I still love you," or anything like that. We were getting too old for that movie shit. But we'd talk about things that happened. Sometimes we'd remember things differently, and we'd start arguing over who was right. But we'd always be laughing. Until one day he just stopped calling. I thought maybe I'd made him mad. Because the last time

we spoke, I'd been joking about the time he got crabs in Vegas. But then weeks went by and I hadn't heard from him. So I started to think that maybe he was in jail or something. But one morning I typed his name on the internet and found out that he passed away. His family was bringing him home to be buried in Newark. I wanted to go to the visitation, but I thought it would be kinda weird if I showed up. I'd be the fly in a bucket of buttermilk. So instead I lit a candle in my apartment and cried the whole afternoon.

I still dream about him almost every night. And I still sleep with a teddy bear that he gave me. He was the only one who ever knew me. It wasn't always good—especially toward the end. But when I was with him I felt like I had a place. When I came home at night, there was somebody who actually wanted me to be there. And you can't just let go of something like that. Especially when you'd never felt it before. And you've never felt it since. Carmine was the only one who ever loved Stephanie.

Not much goes on in this apartment. Nothing really changes but the TV channels. So after a while I started thinking that maybe the show was over for good. And to be honest I was kinda ready.

It's not like I could go anywhere. And nobody was coming over to see me. It was starting to feel like everything that was going to happen to me had already happened. There was nothing left but a bunch of stories. And those aren't worth much when there's nobody to listen.

But then I got this one last gig. Right as the curtain was coming down, I get this one last chance to be onstage. One last chance to be Tanqueray. And I haven't forgotten how to do it. Maybe I can't wear my heels anymore, but I can put on my makeup. And I might not be able to dance but I can talk like I need to talk. To make people smile. To make them laugh. To keep them looking at me—so I can feel like I exist for just a few more minutes, before the lights go out for good. It's just a few minutes. That's how long you've got to hold 'em. It's not very long at all. But if you're doing it right—it can feel like forever.

You were the best I ever had.
-Tanqueray

photo by ever-chicago

Epilogue

Stephanie's life has changed in many ways after she told her story on *Humans of New York*. With the money raised through the telling of her story, she was able to get a full-time health aide. She's had reconstructive hip surgery from one of the best surgeons in the world. She is no longer in pain, and she's determined to walk again. Her current plan is to dance at the book release party, which she wants to have at the Museum of Sex. "You're gonna wheel me in the front door," she says. "And everybody is gonna go crazy. Then I'm going to stand up. And I'm gonna dance. And everybody's gonna go really, really crazy."

The development that Stephanie seems to enjoy the most has been her rediscovered fame. "The gays especially love me," she says. "And a lot of black people too." Collectively she refers to her new fans as "her following." She's printed out business cards with her new slogan: "It don't mean a thang, if you don't got that Tang." She has plans for a new line of hats, with matching masks; "as soon as I get my sewing machine fixed." These days Stephanie gets recognized on the street—a lot. And I get a voicemail every time it happens. She takes full advantage of every interaction to expand her brand. "I'm promoting this book like crazy," she says. "I'm telling people they ain't heard nothing yet, so they better buy a copy." It's clear from the tone of her voice that Stephanie is happiest in the spotlight. But even with all the attention she's gotten, I think the most meaningful impact of the past year has been a more personal one.

If there's anything that's clear from Stephanie's story, it's her candor. But one condition of her storytelling has always been that we respect

the privacy of her two children, and not include details about their lives. (Yes, there were two.) When her story was first being shared, many commenters asked what happened to Stephanie's first son. His name is Mitch. And for most of his life he maintained a relationship with Stephanie. Sometimes it was distant. Sometimes it was close. But by the time I met Stephanie, there had been no contact for a few years. It was clearly a source of pain for her. And I'd always wondered what happened to Mitch.

While the story was being shared on *Humans of New York*, some determined readers discovered Mitch's Instagram account. I reached out to him and we had a long chat. I learned that his estrangement with his mother was based on a misunderstanding. There had been a particularly bad argument, and both were convinced that the other did not desire a relationship. Stephanie asked me to give Mitch her new cell phone number. A couple of days later they spent a wonderful afternoon together, and it was the happiest I've seen Stephanie.

Over the past year they've continued to repair their relationship. "It hasn't always been easy with my mother," Mitch explained. "But I know her story. So I have nothing against her. It's taken a lot of work—but I've arrived in a place of positivity. My worldview is this: At all times, people are doing one of two things. They're showing love. Or they're crying out for it."

—*Brandon Stanton*

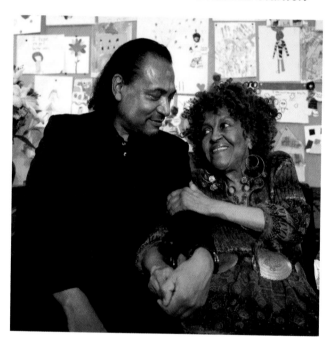

Acknowledgments

From Stephanie

I don't have many people to thank because most of this stuff I created by myself, and to be honest a lot of people fucked me. Men aren't my friends when they find out I won't sleep with them. And most women don't like me. Ronnie Bell was cool. Nobody liked her either. But I want to thank all the dancers who helped me be the top company when I had my burlesque company. I want to thank, what was her name—I'm having a senior moment. Whoever the warden was at Bedford Hills who realized that my case was phony. Ms.

Acknowledgments

Fish, that's it. It's 'cause of her that I got out in nine months. And she gave me that scholarship. I want to thank my godmother, Bernice Peebles. She helped me get through a lot of negative stuff at home. I always wished that she was my mother. She was very understanding. Even when I was doing make-up for cross-dressers, which she thought was kinda weird, she still came to a drag queen show and she loved it. Thanks to Carmine for helping me take care of my kids, and always being there, and buying me my first mink coat. I want to thank the agent Dick Richards, for being the first agent to hire me even though I was a black girl. Thanks to Gloria Leonard for letting me write for the magazine, even though I made up all that stuff. Thanks to Oscar for being like my father and driving me around. I want to thank Assemblyman Gottfried; he's retired now. He helped me fight my landlord for years. Or should I say my slumlord. I'm still catching mice in that place. I want to thank the guys across the hall, Kurt and his husband—Michael, I think. They run Cocktail Caterers. Everyone should give them

business. They're always doing me favors, and they've got these two pussycats that always come to my door and I get to pet them. I was the flower girl at their wedding. I covered the basket with condoms. The after-party must have been something else, because when I got the basket back there weren't any condoms left. Thank you to Mitch. He couldn't be better. And he's been there whenever I need him. My ex-boyfriend Marty was a good guy too. Thanks for all the times he was there for me, especially when things were financially down. When 9/11 happened he gave me $5,000 because he knew I was doing make-up and people wouldn't be coming into the city for a while. That really saved me. I want to thank my surgeon and my doctor, but I can't spell their names. And thanks to Brandon, who was the first person who's ever offered me a big opportunity and didn't try to sleep with me.

From Brandon

Thank you to the whole team at St. Martin's: Jen, Laura, Martin, Jess, Jeff, Paul, Eric. All these

years, and somehow we keep churning out the hits. (We miss you, Sally!) Thank you to Michael Flamini for your exuberant and celebratory brand of edit-ing. Makes book season a lot more fun. Thanks to the all-powerful designer Jonathan Bennett, the hidden force responsible for the beauty of my books. Thank you to David Rotstein; if God writes another book, I'm sure he'll ask you to design the cover. Thanks to Henry, your art made all the difference in this book. Thank you to Elizabeth Seramur, the photo researcher for the historical images. Thanks to my agent, Brian DeFiore, for being the first and last finger-prints on all my drafts. Thanks to my wife, Erin, and my daughters, for keeping life simple and familiar. Thanks to my old friends for continuing to make fun of me. And thanks to Stephanie, for her repeated acknowledgments that I have never tried to sleep with her.

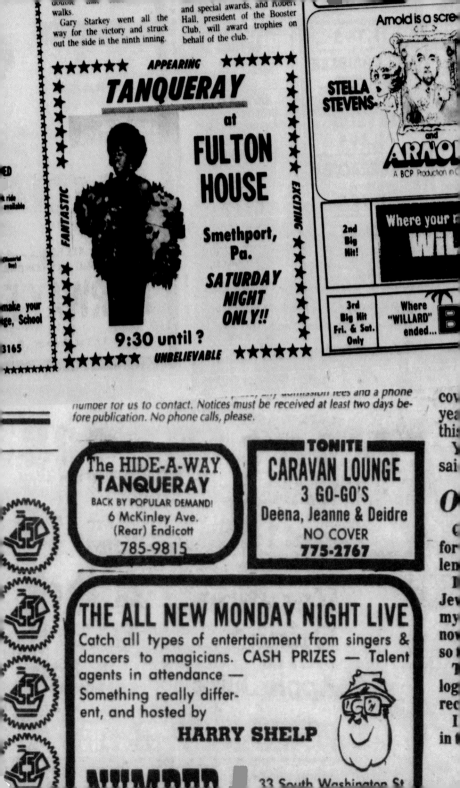

the Clinton Dimes.

The Sons . . . Haven are p . . . a-thon, t . . . sponsorship . . . Carduci an . . . auxiliary.

The walk . . . end their tr . . . ly Home o . . . walk the . . . touching . . . Walkers w . . . sponsors w . . . benefit the . . . by the mil . . .

Anyone . . . walk-a-tho . . . will go to . . . the spons . . .

Mrs. . . . exhil . . . Ikeb . . .

of" repeat, Johnny hosts nthony Newley and Char-

. . . ania Fish Commission would . . . be at the Ridgway Post Office at . . . 1 a.m. with the fish for the . . . waters.

. . . bby Grange.

are . . . close to